CENTRAL BRISTOL

THROUGH TIME

Anthony Beeson

AMBERLEY

Acknowledgements

I should like to thank my ex-colleagues Jane Bradley and Dawn Dyer of Bristol Reference Library for their permission to publish images from the Bristol Local Collection in this volume. Thanks must also go to Jacqueline Claridge, Mia Hale, Antony Keyworth Berridge, John Williams and Michael Tozer for the use of further images.

Andrew Foyle was kind enough to provide me with details from his unpublished research into William E. Studley. I am most grateful to all.

To David Charles O'Neill
Fuimus Troes, Fuit Ilium, et ingens Gloria Teucrorum.

First published 2012

Amberley Publishing
The Hill, Stroud
Gloucestershire, GL5 4EP

www.amberley-books.com

Copyright © Anthony Beeson, 2012

The right of Anthony Beeson to be identified as the Author of this work has been asserted in accordance with the Copyrights, Designs and Patents Act 1988.

ISBN 978 1 4456 0825 9

British Library Cataloguing in Publication Data.
A catalogue record for this book is available from the British Library.

Typeset in 9.5pt on 12pt Celeste.
Typesetting by Amberley Publishing.
Printed in the UK.

Introduction

Brycgstowe, 'the place at the bridge'; a city of destiny. This could hardly have seemed possible, however, to Bristol's Saxon founders in the tenth century, who formed the nucleus of the settlement on the ridge now occupied by the ruins of the churches of St Peter and St Mary-Le-Port. The establishment of a harbour near the confluence of the rivers Avon and Froom saw the start of a trading and maritime tradition that would elevate the city to become the second most important port in the country. There can be few English cities with such dramatic natural scenery at hand as Bristol, and the approach from the Severn to the city through the scenic drama of the Avon Gorge, with its huge tidal range, must have impressed and astonished all who visited by sea. Geographically split between the counties of Gloucestershire and Somerset, the city had received a Royal Charter in 1155 and was made a county in its own right by Edward III in 1373. The latter still causes confusion and the author (when still a librarian) can recall trying to convince a totally disbelieving and officious female on Tony Blair's staff at Downing Street, who had enquired which 'shire' claimed the city, that Bristol was in no other county but its own!

This volume is arranged geographically as a series of six walks. One starts from Bristol Bridge, while others commence in Broad Weir, Christmas Street, Temple Gate, the Centre and on Canons Marsh. The images in this book are a personal choice. Most come from the superb collection held in the Bristol Central Reference Library's Local Collection, but others are from the author's own collection and other private collections. Many are previously unpublished. The earliest capture something of the old city that was then fast disappearing. What they cannot convey is the colour of the façades, the ochres, pinks, reds and whitewash with which they were coated, and all too soon blackened in the polluted air. Neither can they allow us to appreciate the smells that fouled the air from the rivers and their banks at low tide. By the mid-nineteenth century it was not uncommon for the summer river smells to beset residents high above it in Clifton, preventing them from opening their windows on hot summer days. Semi-rural residents in smart new houses could also find themselves beset by fields awash with sewage as was the case near Alma Road where several sewers discharged.

Bristol prospered through the later centuries from its manufactures and the acumen of its people, who were mocked for their rage for profit. Important voyages of discovery started from its port. Trade with the colonies, including the dubious Triangular Trade, only added to the wealth of this industrial and maritime city. The coming of the railway in the 1840s and Bristol's association with Brunel was a welcome boost at a time when it was losing dominance as a port to other cities.

The last century has seen the greatest change in Bristol than in any preceding it. The layout of a large part of the central area has for the most part changed, as have the city's traditional industries. The opening of the Royal Portbury Docks at Portishead in 1972 heralded the closure of the city docks to large commercial shipping and redundancy to the many warehouses and attached buildings that have been adapted to other uses. The closure led to a gradual gentrification of the dockland and its adaptation to become a wonderful leisure facility for Bristol, with houses and arts facilities. Some opportunities have been lost, as in the Canons Marsh development, where too many office buildings form a sterile waterside barrier between the humanity of the historic city and the new domestic quarter, but the overall effect of the city's waterside is uplifting. Projects such as the restoration of Queen Square have added greatly to the pleasant ambiance of this part of Bristol. The 1950s Broadmead development gave way in part in the 1980s to the Galleries shopping centre, pedestrianisation, and to a vast rebuilding and expansion known as Cabot Circus that opened in 2008. The founding and expansion of the University of Bristol and the other educational establishments has brought great numbers of young people to the city and greatly enriched the academic and popular culture of Bristol. As is generally the case in university towns, such influxes liberalise a society. Bristol is by no means a perfect city, but it is a very pleasant one.

Walk 1

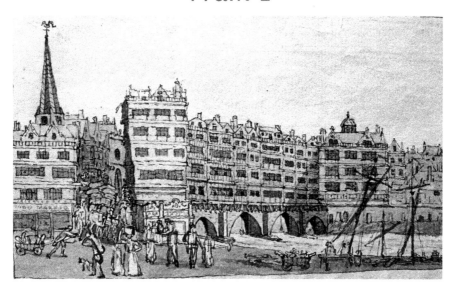

Bristol Bridge from St Nicholas Back Before Demolition in 1761

The wealthy, multi-storeyed Elizabethan and Jacobean houses were supported on beams projecting from the medieval bridge and, unlike on London Bridge, the façades facing the river were elaborate and built to impress. The roofs and leads were used for taking the air and drying washing. The house on the central pier, with its gables parallel to the line of the bridge, was converted from the chapel of the Virgin Mary. Accidents and jams were daily occurrences on the bridge. The houses at the city end doglegged around to the Back. On the right was the 'Great House at the bridge end' and on the left St Nicholas Gate, which formed part of the church. The gate was removed in 1762 and the church rebuilt.

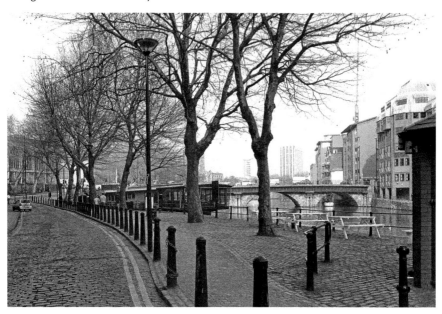

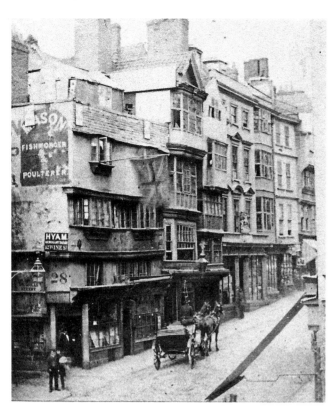

Carriage Trade at the Druid's Arms, 1850s

At the junction of High Street and Nicholas Street. The adjoining handsomely jettied and gabled building with a lantern was the Angel Inn, which had an additional frontage on Nicholas Street. It was said to be the oldest hostelry in Bristol and had in its earliest days been called the Bull. A carving of the same animal ornamented a first floor fireplace. The Druid's Arms was demolished by the Council in 1864 in order to widen the end of Nicholas Street, but the Angel was so weakened by this that it collapsed the following year. The obelisk-shaped entrance on the right in the modern photograph leads to a series of historic cellars preserved below High Street and Wine Street.

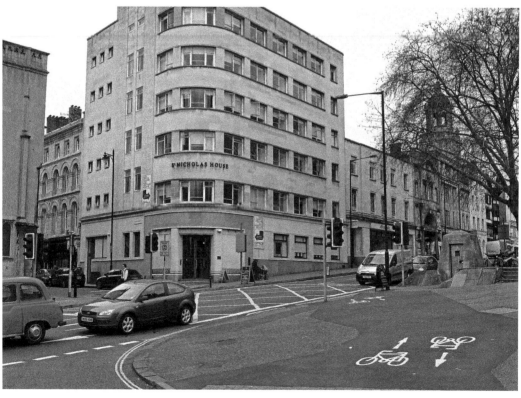

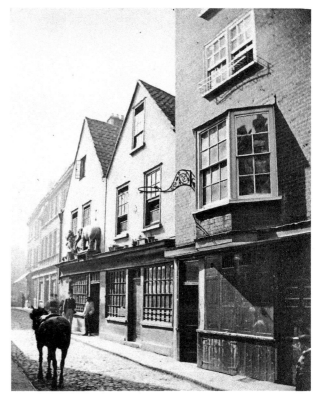

**The Elephant in Nicholas Street,
c. 1860**

Totally rebuilt to a design by
Henry Masters in 1867, with
sculptural decoration on the
façade by Mr Porter, the original,
probably half-timbered, building
sported Georgian fenestration and
a rather more endearing wooden
elephant. The Georgian shop
adjoining the hostelry with the
superb light bracket was rebuilt
by Ponton & Gough in 1863 and
became Gresham Chambers. It is
ornamented with four delightful
heads representing the Seasons.

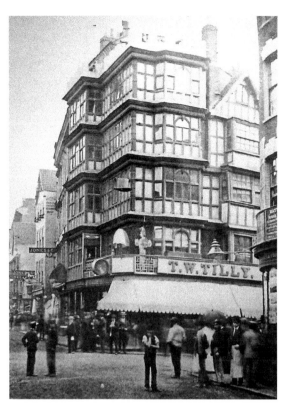

The 'Dutch House'

This seventeenth-century house on the corner of Wine Street and High Street became one of the 'sights' of Bristol. It had no real history and, after domestic use, served as a bank until it was taken by the hatter T. W. Tilly in the 1850s. The building's fame stemmed from his story that it had been imported in sections from Holland. This story probably was based on London Bridge's Nonesuch House that was said to have been imported from Holland. Tilly added battlements, a cannon and a painted grenadier dummy-board sign. The Council bought it in 1900, intending demolition for road improvements. On several occasions in 1908 it was only saved by one vote; they then decided to renovate it. Although badly damaged in the air raid of 24 November 1940, much of the façade was still standing. It was pulled down.

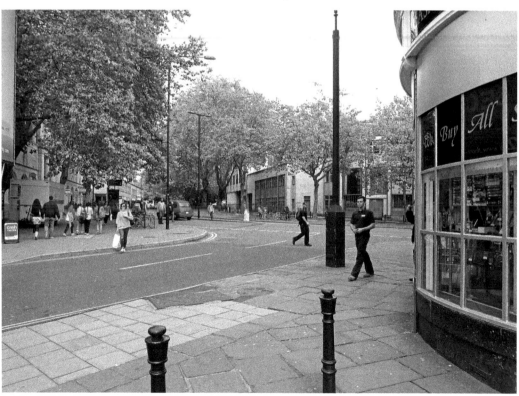

Barnard & Co.'s Tobacco Warehouse, St Mary-Le-Port Street
The splendid, glass-fronted seventeenth-century premises, photographed by Charles Horton from Cheese Market before demolition took place in 1904. The street is first recorded as having been paved in 1490, but it was one of the earliest in the city. Until the late nineteenth century, when expanding department stores began to replace the timber-framed buildings, it had been extremely narrow and, especially at the High Street end, the opposing jettied upper storeys came within a few feet of each other. One of the properties had belonged to the Company of Brewers and was ornamented with their arms. All but one building was lost in the Blitz and the street later erased in redevelopment.

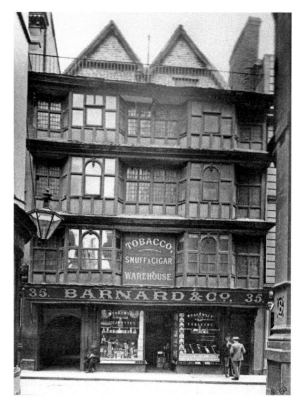

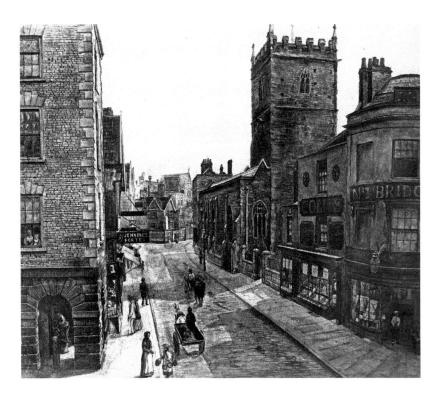

Peter Street from St Mary-Le–Port Street, *c.* 1855

A watercolour of one of the most ancient Bristol streets and the site of the earliest settlement around St Peter's church. Bombed in the Blitz, it was levelled and now forms part of Castle Park. Originally called Castle Street, it led to the castle barbican that stood approximately where the road later forked, giving access to Castle Green and Castle Mill Hill on the left and the new Castle Street on the right. Until the 1890s St Peter's Pump stood under the rusticated arch on the corner of Dolphin Street in the left foreground. It replaced the ancient pump and cross removed during improvements in 1766 and now at Stourhead.

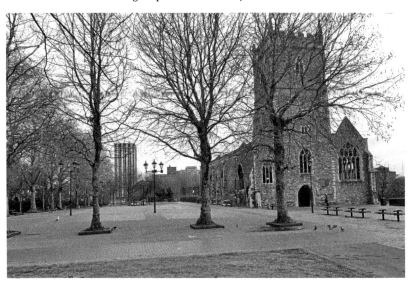

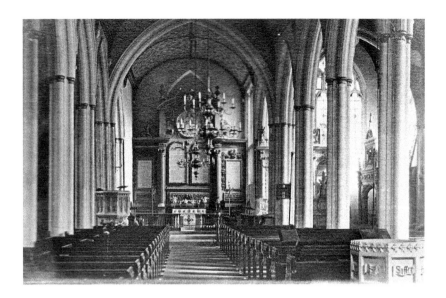

St Peter's Church, 1870

Seen here at the height of its Victorian splendour after restoration in 1870 when furnishings had been expensively replaced. A Saxon foundation, it had three aisles with the chancel backed (and its window blocked) by John Mitchell's wooden 'Corinthian altarpiece' of 1697. Bristol's churches were famed for their brass chandeliers some of which were of great antiquity. In the right distance may be glimpsed the effigy of Martha, the wife of Robert Aldworth, on their magnificent tomb of the 1630s. The columns of a sumptuous Jacobean tomb to one of the Newtons of Barrs Court may be seen far right. Gutted in the 1940 Blitz, unbelievably the damaged monuments were left exposed to the elements until 1958 when the remains were rescued. Today, the untidy and seemingly permanently locked shell of the church is dedicated to the victims of the Blitz.

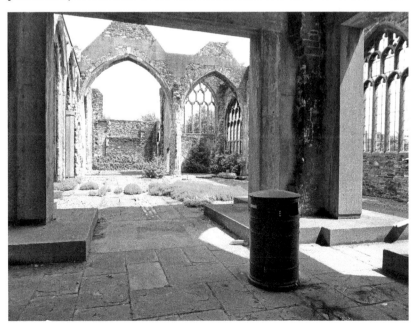

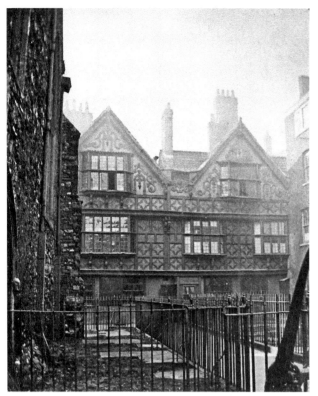

St Peter's Hospital, 1870s

In 1607, Bristol's first sugar refiner, Alderman Robert Aldworth, purchased an ancient mansion adjacent to St Peter's church, overlooking the Avon & Bristol Bridge. By 1612 he had reconstructed part and produced one of the most marvellous Jacobean domestic façades in England, complete with a display of carved brackets, bargeboards and pargetting. The interior was similarly elaborate with carved and panelled rooms.
In 1696 it was acquired by the Corporation and for two years became the City Mint before becoming a workhouse and the Bristol Incorporation of the Poor's administrative centre. Its destruction in the Blitz was the greatest architectural loss suffered by the city.

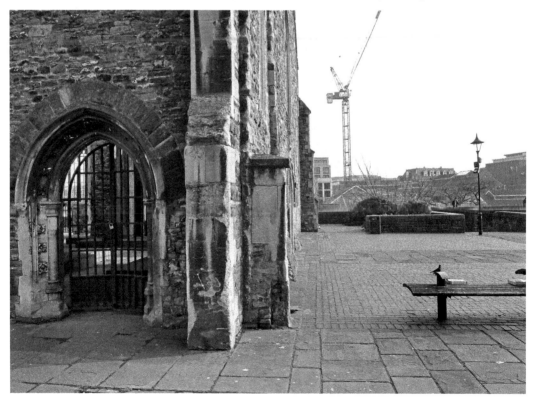

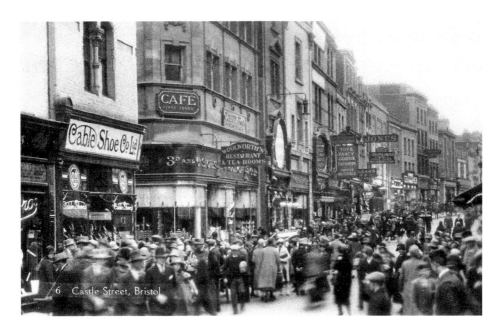

6 Castle Street, Bristol

Castle Street, 1920s

This popular shopping area in pre-war Bristol was so busy that traffic was banned from it at certain times and some shops stayed open until 10 p.m. to catch trade. Laid out around 1658 on the site of the inner ward of the castle, it offered a direct route into the city from Old Market and was central to a commercial axis that spread from beyond West Street into the heart of the city and continued up to Whiteladies Road. Badly damaged in November 1940, some shops, however, continued trading until the 1950s. Against great opposition from small independent traders, but encouraged by the large chain stores, the Council moved the commercial heart of the city to Broadmead, obliterating historic streets and buildings there untouched by the bombing. In 1979 the site of the street was incorporated into a new open space called Castle Park.

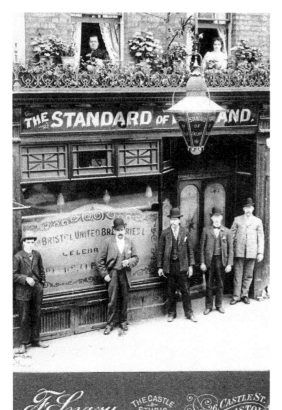

The Staff of the Standard of England on Parade, Castle Street, c. 1900
Landlord George Williams (far right) stands beside his son Frederick while wife Sarah and daughter-in-law Charlotte peer out across a flower filled balconette. Originally an ale store built over the castle well, the rebuilt pub, near Old Market, boasted stained glass union jacks and a skittle alley among its attractions. Three dogs, successively named Punch, collected coins that were thrown to them and then deposited them in a dish behind the bar. Monies raised went to the Bristol Hospital for Sick Children & Women and the dogs received medals for their efforts. Punch II sits at George's feet, slightly out of shot. The pub was destroyed on 24 November 1940 by an explosive bomb and fire. The change in the till melted into a single lump in the conflagration. Landlady Charlotte then took over the Portcullis in Clifton until 1949.

'Gollywogs!'

Itinerant street traders were once commonplace; Samuel Loxton's 1906 drawing shows a Bristol toy-seller selling pale-faced Egyptian-style Gollywogs. In the 1880s when Britain occupied Alexandria, the native workers were known as 'Ghuls' (or ghosts) to the troops and wore armbands bearing the letters WOGS (Working on Government Service). Troops soon began calling these workers 'Ghuliwogs' and, when local rag dolls were purchased as souvenirs, they were taken back to England, thus introducing the name and copies as this drawing suggests. Loxton shows a detail of the bearded toy that is possibly the only surviving record of the type. The seller's 'Gollywogs' are stringed like marionettes and one also appears to have a tail. The itinerant trader's place has nowadays been replaced in Bristol by the stalls of the Farmers' and Craft Workers' Markets and retailers such as the toy-seller Sue Lowney pictured here.

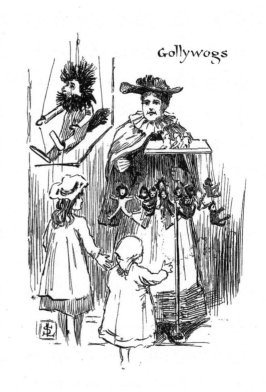

Gollywogs

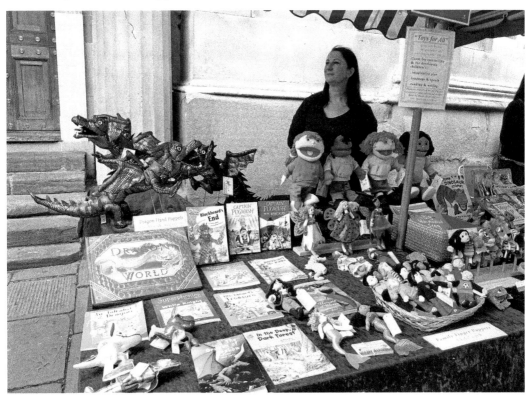

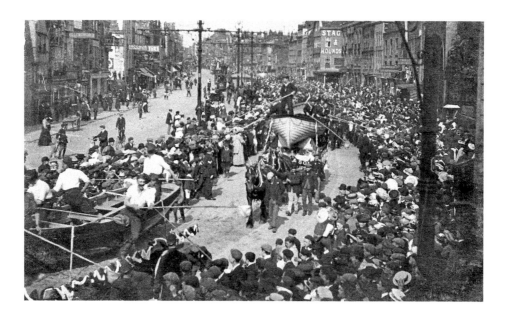

Old Market Street on Lifeboat Saturday, 1899

This was once a thriving shopping area that joined Castle Street and shared in its popularity and prosperity. The Stag & Hounds on the right was the setting for Bristol's Pie Poudre (Pie Powder) Court that was officially abolished in 1971. It had been banned in 1870 following riotous and drunken ceremonials. The street escaped the Blitz only to be fatally damaged by Bristol's post-war planners. The inner ring road severed it from the rest of the city more surely than the castle walls had once done. This, combined with relocating the commercial heart of Bristol to Broadmead, with no easy or natural pedestrian connection, dealt it a blow from which it has never recovered. Bristol followed Manchester and Lifeboat Saturday started in the city in 1894, becoming an annual fundraising event for the service. It was the first official street collection for charity.

The Lamb Inn in West Street, Old Market by Horton

Seen here before its demolition in 1905, the inn stood just beyond Lawford's Gate. Built around 1651 it was the scene of some amazing supernatural happenings in 1761 that centred around the two young daughters of the landlord Richard Giles, and were later recorded and published by Henry Durbin who had witnessed some of the manifestations. Although dismissed as trickery by Victorian authors, many of the manifestations before reliable witnesses remain unexplained. The original and elaborately panelled double doors led to the long inn yard under the carved figure of a lamb.

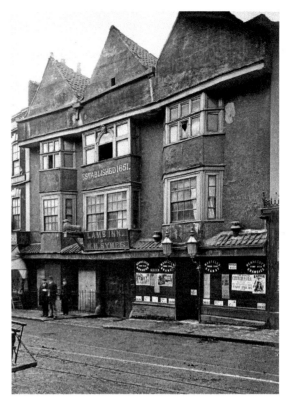

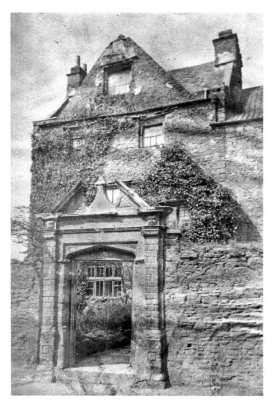

Tilleys Court, Barton Hill, 1893
This house, architecturally notable for its early classical details, certainly predated a map of 1610 that featured it. Sir Thomas Day, the soap manufacturer, sugar refiner, benefactor, local politician and MP, lived here. It was known locally as 'Queen Anne's House'; an unproven legend arose in the nineteenth century that she had rested here before entering the city. Confusion probably arose because Day also owned the spectacular Great House at the Redcliffe end of Bristol Bridge where, in 1702, he entertained Queen Anne. He died in 1709 aged eighty-one. Tilleys Court was demolished in March 1894 for the purpose of erecting a Board School on the site. After its demolition the road name was changed from Barton Hill to Queen Anne Road.

Walk 2

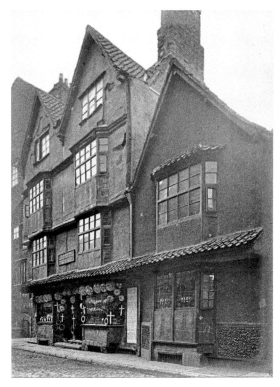

The Rising Sun and Hawkins the Fruiterer in Ellbroad Street, *c.* 1880
The Rising Sun was an inn that dated back to 1606. Its main frontage ran along Lower Castle Ditch, but it also turned the corner into Ellbroad Street where both thoroughfares joined at Broad Weir. The building was demolished in 1906 and its replacement opened in 1909. The shops that replaced this successor in 1954 fell prey to the new Holiday Inn building in 1970. Hawkins the fruiterer and flower dealer occupied No. 2 Ellbroad Street, the large, double-fronted seventeenth-century house adjoining the pub. They specialised in wreaths and crosses made to order and the galvanised containers for these may be seen hanging outside.

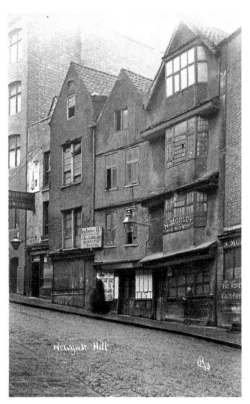

Ancient Houses on Castle Mill Street, Newgate Hill, 1900

The New Gate to the city had spanned the road at the far left until the mid-eighteenth century. Adjoining its inner wall, and approximately where the tall warehouse appears at the left of the picture, had stood Newgate Prison, described as 'white without and foul within'. It was closed in 1820 and the site soon redeveloped. The Castle Mill that was turned by the waters of the Froom stood at the foot of the hill.

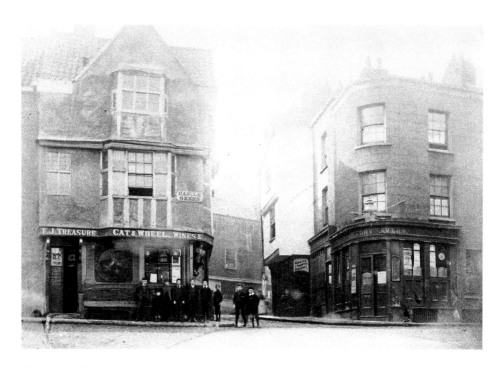

The Cat & Wheel – 'Catherine Wheel'

This sixteenth-century inn at the entrance to Castle Green was unfortunately demolished in 1900. The pub sign, of a cat and wheel between Jacobean pilasters, was painted on the wall next to the front door. This was probably the result of a local act of Parliament in 1792 that compelled the removal of all projecting and overhanging signs in the city. The elaborate carved elm corner bracket in the guise of a satyr, an orgiastic companion of Bacchus the god of wine, was fortunately saved and is now in the collection of the City Museum. Francis Treasure was the landlord between 1890 and 1894, which helps to date this photograph. The Victory Tavern on the opposite corner dated from late Georgian times.

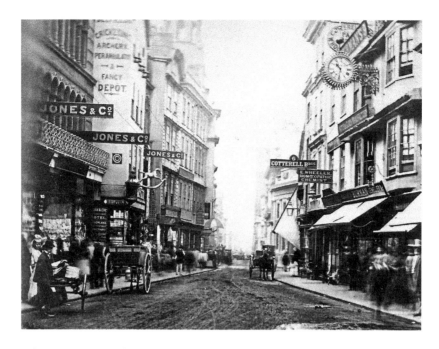

Wine Street towards Corn Street, *c.* 1882

Seen from the Wine Street Pump that remained in the centre of the road until 1887. The street was dominated by 'extensive drapery establishments', paramount among which was Jones and Co., on the left. Their recently rebuilt premises replaced the old city Guard House that had become Bristol's central police station in 1836. The plethora of large ornamental shop signs illustrates how the 1792 Act banning them had long been flouted. Many of the ancient houses had flat roof spaces and these leads were used for recreation or sometimes planted with tubs such as over the jeweller's on the right. Until 1733 the magnificent painted and gilded Civic High Cross had stood at the interchange of Wine, Corn, High and Broad Streets, providing a city focus. A replacement would be welcome today.

Small Street, c. 1877
The fine medieval and heavily jettied house had become C. J. Hill's shirt and glove emporium, hemmed in by Georgian façades. Earlier images of this street suggest that the building on the left was really a half-timbered property with a modern frontage added. A street sweeper stands near his broom by a branch office of the *Times and Mirror* and the Exchange teahouse. The Corn Exchange may be glimpsed beyond these, and at this time the walls of St Werburgh's church still backed the viewer of this scene.

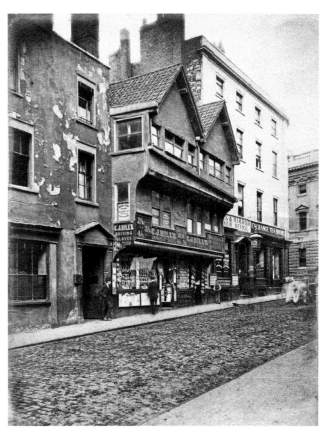

23

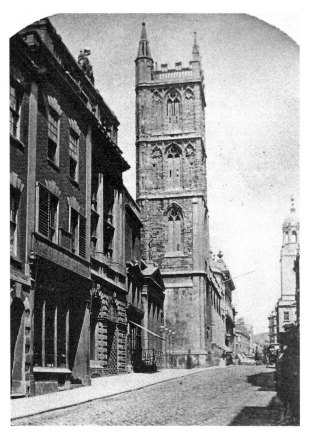

St Werburgh's Church in Corn Street

The church was a twelfth-century foundation in honour of a Mercian saint, rebuilt in the fifteenth century with a splendid tower and further altered in 1760 when the chancel was demolished. By 1871 not a single ratepayer remained in the parish, thus an Act was obtained for the church to be moved to a suburb where it would be used. In 1878 it was dismantled and rebuilt in Mina Road. The photograph, taken in the 1860s, shows C. A. Busby's Commercial Rooms of 1810, with their original lamp standards, and in the distance Gingell & Lysaght's West of England & South Wales Bank of 1854–58. An oversize office block now dominates the Commercial Rooms.

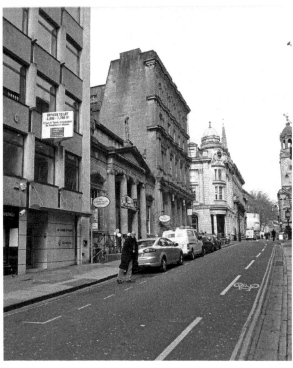

The Dutch House and Wine Street, *c.* 1893

In this view, from a lantern slide, the leads or roof terraces of the Dutch house are clearly visible. In 1883 a Wine Street tradesman was summonsed for showing magic lantern slides on a screen erected on his roof in a public display that lasted several hours. It caused Wine, High and Broad streets to be completely blocked for the duration and the shouts of the spectators frightened a horse sufficiently that it threw its passengers from the carriage. Jones's ever-expanding buildings may be seen on the right and a hoarding to the left advertises 'The City Mourning House for mourning clothes'. Wine Street narrowed inconveniently to the east as may be seen in the distance. It was widened in 1894. Originally called Wynch Street after the pillory that stood here, it also saw several particularly gruesome executions and punishments.

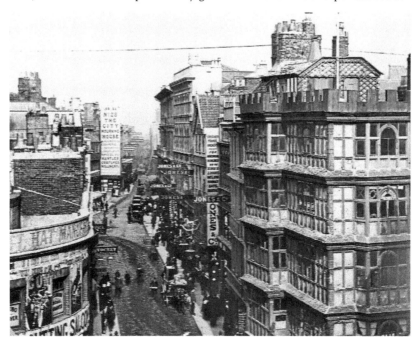

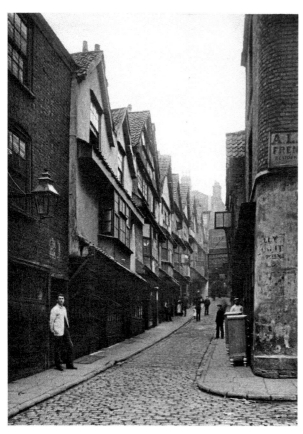

The Pithay in 1898 Before Demolition

This ancient street ran from Wine Street down to the Aldrych or Pithay Gate in the city wall with its inhabited bridge spanning the Froom. Originally called Aylwards Street after a local family, its current but ancient name comes from *puit*, a well or hollow and *hai*, a hedge or enclosure of stone. During demolition works for an extension to Fry's chocolate factory, over 370 feet of Norman town wall was found. By the nineteenth century the ancient houses accommodated many firms dealing in furniture and old clothing. The modern Pithay strains the imagination to find any point of interest.

Union Street Bridge and the Froom, 1835
J. S. Prout's lithograph looks towards
Union Street from Fairfax Street, which
has covered the River Froom since 1860.
The Pithay is behind the viewer. The outer
wall of medieval Bristol that connected
Small Street with Newgate ran along
the right bank of the river and a flight
of steps ascended from its ramparts to
join Union Street. The house on the right
perches picturesquely on one of the wall's
bastions. Excavations in 2000 discovered
the remains of a twelfth-century extra-
mural house of two storeys to the left
of the picture. The noisome condition
of the Froom in the past led to it being
covered over here and elsewhere, but it
is a great pity that modern developments
in Broadmead could not have included
its resurrection in part as an ornamental
watercourse. The area pictured today
cannot be considered picturesque.

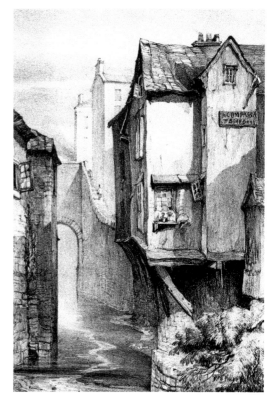

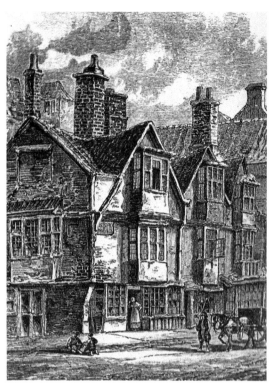

Broadmead and the Corner of Old King Street (Now Merchant Street), *c.* 1800
Once called Newport Meadow, it was later known as Brode-mede, and was a wide meadow beyond the city wall through which the Froom ran. It occasionally flooded disastrously in the following centuries. By the end of the twelfth century the first houses were built on the land. From 1731 market stalls that had previously been erected in Wine Street during the St James Fair were banished to quieter Broadmead. In 1791 the Corporation decreed that all streets should have name boards as appears on the engraving. After the Blitz had seriously damaged Bristol's main shopping streets a new plan relocated the retail heart of the city here, notwithstanding much opposition from small traders. Pedestrianisation has improved the ambiance of the area greatly, and the modern photograph shows a hurdy-gurdy player entertaining at the interchange.

Ridley's Almshouse at Milk Street and Old King Street

This dated from 1739–41 and had been given by Miss Sarah Ridley in memory of her brother and herself. In 1819 it was described as 'a neat building of freestone for five bachelors and five maids, each of whom receive 9s per fortnight'. The watch house outside, converted to a newsagent/tobacconist, was a rare survival of the many that had once played an important role in the early policing of Bristol. It was demolished before the 1920s and the almshouses, after war damage, in 1954 for the Broadmead development. The placards in Horton's photograph declare Boer War peace negotiations and the explosion on HMS *Mars* on 14 April 1902.

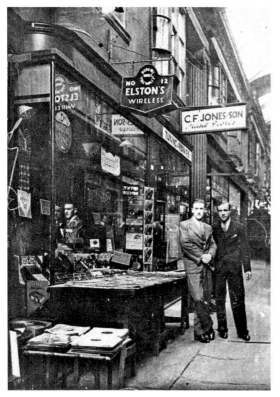

The Upper Arcade, Late 1930s

Two smart young men pose outside of C. F. Jones & Son, musical instrument dealer's, and Elston's wireless shop at Nos 11 and 12 of the Upper Arcade. The arcades were opened in 1825 and 1826 respectively as the St James's Upper and Lower Arcades, designed by James Foster 'for the better accommodation of foot passengers'. They boasted Ionic columns and a lofty glass canopy. The Upper Arcade sloped from St James Barton to the Horsefair; the Lower then continued the walk to Broadmead. Never achieving the original desire of attracting aristocratic young customers, the shops were often taken on short leases by travelling portrait artists. In the 1930s they were full of antiquarian booksellers, gilders and carvers, wireless and music dealers. The Upper Arcade was Blitzed and replaced by a soulless and windswept walkway.

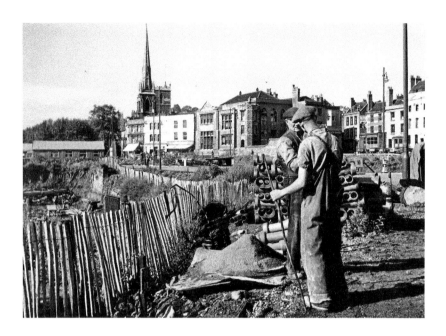

Excavations at St James Barton for New Department Stores, *c.* 1953
Workmen stand on the site of Barr's Street while beyond are the historic buildings of St James Barton, untouched by the Blitz but soon to be swept away for 'road improvements' and the new bus station. The Elton town house of 1728 may be seen far right, while a gothic style school appears centrally where the monolithic Avon House (now the Premier Inn) would rise. The building excavation uncovered many of the burials of St James churchyard that had formerly stretched to Horsefair. So crowded was the cemetery and so shallow the interments in this section of the yard that in erecting booths for the annual fair once held on the site, portions of recently buried Bristolians surfaced. Treading on fragments of the dead was an all too common occurrence at the fair.

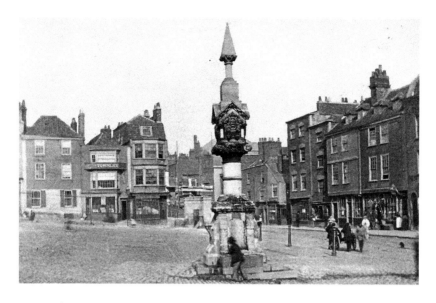

Haymarket, *c.* 1868

'A somewhat costly fountain that does more credit to the kindness of heart than to the taste of the donor.' Originally part of St James Churchyard and the scene of the annual fair, by the 1860s this triangular area, surrounded by a charming collection of buildings, had been paved. On Tuesdays and Fridays it became the hay and coal market. The entrance wall of the Lower Arcade in Horsefair may be glimpsed behind the fountain's column. The Rose & Crown is the second building to the left of the fountain in St James Churchyard. The name of the landlord 'Townley' is on its façade and dates this photograph by W. H. Barton between 1867 and 1869. This area survived the bombing of the Second World War war only to fall prey to Bristol planners. Department stores now cover much of this scene.

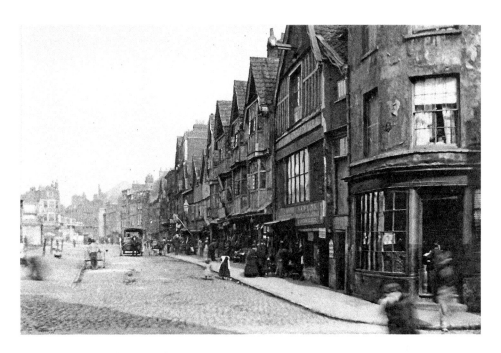

The Horsefair in the 1860s by W. H. Barton

Before the cutting of lower Union Street through the existing buildings of Broadmead to aid access to Horsefair, the buildings of the latter thoroughfare stretched in an unbroken line along the edge of St James churchyard in a wonderful assortment of vernacular styles as seen here from the corner of St James Back (now Silver Street). In the far distance may be seen the bright ashlar stone wall flanking the entrance to the Lower Arcade. Behind this towers the roof of Old King Street Baptist chapel. At the far left of the photograph a stone watchman's box sits on the paved surface of the churchyard. The street's name enshrines an early use of the area.

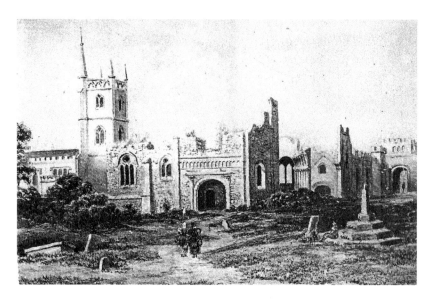

St James Priory in the Early Seventeenth Century

Medieval Bristol was encircled with religious foundations, the earliest of which was the Benedictine Priory of St James, founded around 1129. The church is believed to be the earliest standing building in the city. Following dissolution, the monastic buildings fell into disrepair and gradually disappeared. This painting, reputedly in the British Museum, shows many of them. The Lady Chapel attached to the choir appears in the foreground to the right of the tower. The imposing Norman gate tower in the centre presumably gave access to both the chapel and the cloister, the vaults of which appear beyond along with the adjoining chapter house. Around the truncated churchyard cross the notorious annual St James Fair took place until 1837. Beautifully restored and developed between 2009 and 2011 St James is now a charity providing residential help for people with addictions.

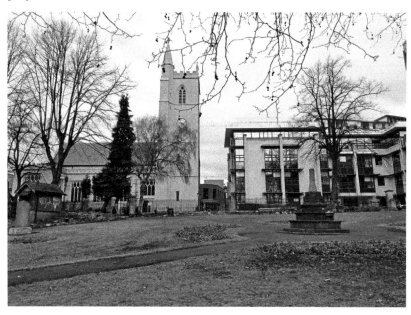

St James's Churchyard and the Steps to St James Parade, *c.* **1880**

Most of the city's burial grounds were officially closed in January 1854 in an attempt to stop the spread of disease caused by severe overcrowding of the dead. St James churchyard, being the oldest in Bristol, was particularly bad, and generations of Bristolians had added to the problem as can be seen by the height of the rail-topped wall retaining the internments above street level. There was a demand for burial at this section of the churchyard as there was less chance of being accidentally resurrected during the annual fair. Lack of space in city graveyards resulted in bodies being interred in very shallow graves and it was not uncommon to find bodily fluids seeping out of churchyard walls.

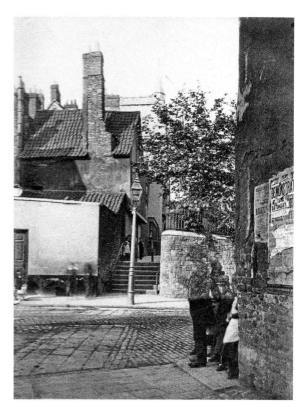

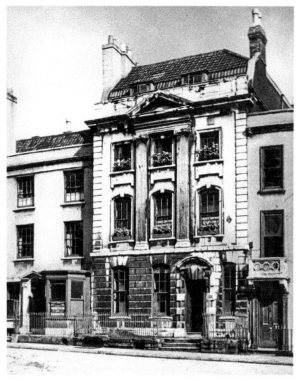

The Elton House of 1730

In 1955 many were shocked by the Council's intention to demolish 12 St James Barton. Sir Abraham Elton had offered it to the city in 1778 and at one time it had nearly become the mansion house. The work of John Strahan, the architect of similar houses in Prince Street, it had been scheduled by the Council for the Preservation of Ancient Bristol. Having survived the war unscathed, it fell foul of Bristol Bus Company's demands for its demolition to facilitate access to the new bus station. The Council, alarmed by the level of public protest, allowed demolition of all but number 12 and its neighbour. They soon, however, rescinded on this decision and demolition followed.

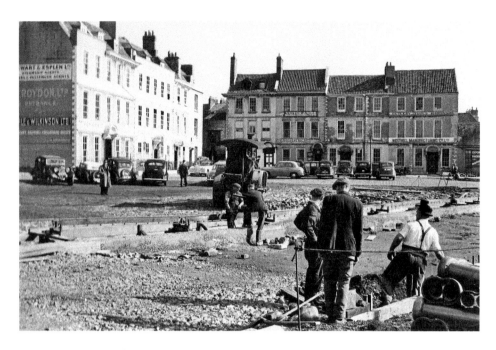

St James Square Before Demolition in 1968

Built between 1707 and 1716, this was the second of Bristol's great squares to rise and was a remarkable pre-Georgian construction of brick-faced houses with details in stone and wood. Most of the front doors had elaborate shell hoods and the square itself was cobbled. Part of it was damaged in the Blitz and was subsequently demolished to make way for the St James Barton roundabout and the new central ring road that destroyed the historic and commercial connection and benefits that such areas as Old Market and Stokes Croft had previously enjoyed. Isolated by underpasses and dislocated from the natural flow of pedestrians, these previously vibrant commercial areas sank into decline. The remaining north-east corner of the square was wantonly destroyed in 1968 as one of the wings of Avon House North (now the Holiday Inn) rose behind it.

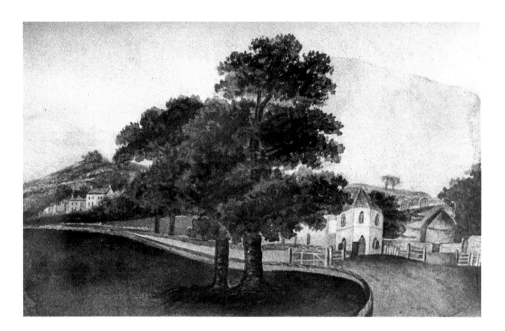

Stokes Croft Gate, 1792

A naive and previously unpublished watercolour showing the Gothick toll-house that commanded the confluence of what are now the Cheltenham and Ashley Roads. The buildings in the left distance are those associated with the remarkable Rennison's Baths. These open-air swimming baths, with adjacent tea gardens, bowling green and inn, flourished from the 1740s and provided both polite and more licentious entertainments to Bristolians beyond the city boundaries. The baths were finally closed in 1916. The hill beyond had already gained the name 'Montpelier' by this date for its views and its adjacent baths, an allusion no doubt fostered by the memories of aristocratic visitors to the elevated French spa of Montpellier. The toll-house was replaced in 1867–70 by the row of shops known as Golden Cross.

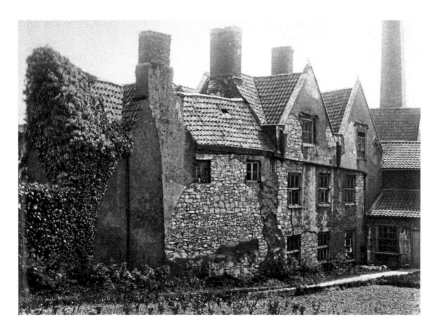

Ashley Manor, or Hooke's Mill Mansion, Sussex Place

Dating to the Tudor period, some sources claim that Ashley Manor included a property owned by St James' Priory. It stood close to Hooke's Mill, and had belonged to the wealthy brewing family of that name, who embellished the property upon purchasing it in around 1640. It was sold in 1731 and let; tenants included the Magdalen Charity and the Blue Maids Orphanage, which purchased it in 1825 but subsequently moved its charges to a new building. Not being properly maintained, the house decayed and was demolished in 1911, notwithstanding the fact that it was structurally sound and a unique survival for the city. Doors, panelling, ceilings, chimney pieces and a great staircase were stripped out and sold. Those items secured by the city museum are now presumed lost, although the Red Lodge preserves a door and a chimney piece.

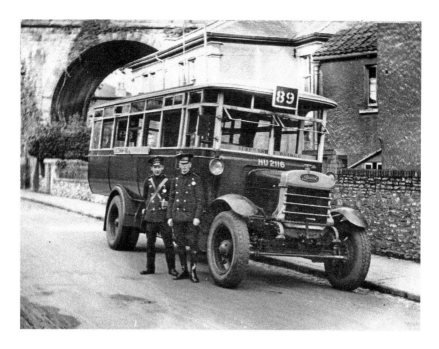

As Smart as a Chauffeur

Twenty-seven-year-old Gilbert Sobey (1900–1980) and his conductor pose beside their omnibus at its terminus in Kingsley Road on 25 November 1927. Bristol Tramways & Carriage Company's service No. 89 ran between Cheltenham Road and the Clifton Suspension Bridge. The bus company traced its origins back to 1875, when the Bristol Tramways Company was formed by Sir George White. In 1908 the company started manufacturing its own buses, which soon became the most widely used in Britain and were also exported abroad. The famous Bristol scroll logo on the vehicle's radiator was adopted from that of White's Bristol Aeroplane Company to commemorate the building of Bristol Fighters at the Tramways' Brislington Works during the First World War.

Walk 3

The Wheatsheaf, Christmas Street

This 1940s building was demolished in June 1970. It had replaced the late Georgian Wheatsheaf Hotel. Its only real merit lay in the carved relief of its namesake above the entrance, but both it and its neighbour retained the domestic scale that linked Christmas Steps with St John's Arch. The Wheatsheaf of 1775 had not extended as far as Nelson Street. Christmas Street was formerly Knifesmith Street, inhabited by cutlers. Nelson Street, once Haulier's Lane, had previously been rather alarmingly known as Grope Lane. The city's re-alignment of Rupert Street and the redevelopment of the 1970s was particularly unfortunate for this historic area and produced buildings of appalling ugliness and overpowering scale. In 2011 the Council gave Nelson Street over to a street art project entitled 'See No Evil' in an innovative attempt to turn an architectural sow's ear into a silken purse.

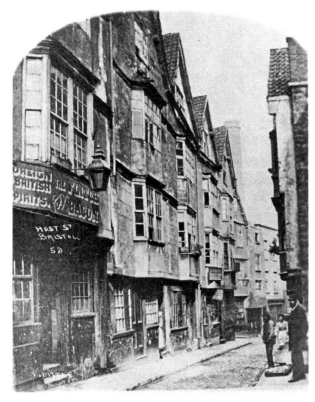

Host Street, Early 1860s
Originally called Horse Street, this was a major route out of the medieval city, both to the Abbey of St Augustine on College Green, and via Steep Street, which branched off to the left, and St Michael's Hill to Gloucestershire and the Severn Ferry. It must have witnessed many civic and state processions and its importance may be judged by the fact that it was one of the earliest streets to be paved in the Middle Ages. Victorian street improvements swept away the humanity of the street; modernity has not improved it.

Steep Street, from Host Street, 1850s
Anciently the major route to the ferry over the Severn and called 'Stripes Street', it was the scene of royal and civic processions and of a Civil War skirmish. So unsuitable was it for mailcoaches that the house adjoining the steps to Trenchard Street had to be chamfered off to allow passage. A splendid eighteenth-century wooden sweep's sign that survived the 1792 ban on such advertisements may be seen at the turning of the street; his handcart waits below. The tall, jettied building in the centre was the Ship Inn, built after the siege of 1643. The street was demolished from 1871 to make way for an extension to Foster's Almshouses, and its place usurped by the convenient, if sterile, Colston Street.

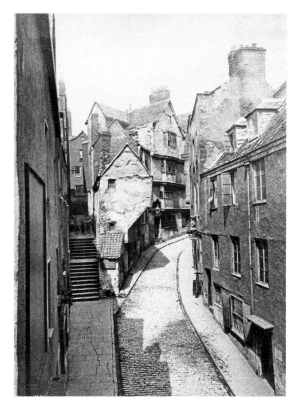

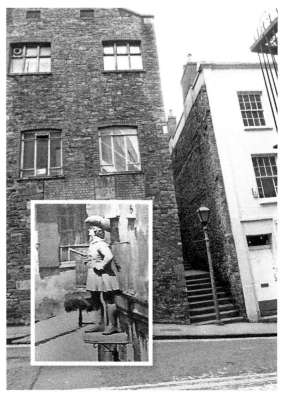

43

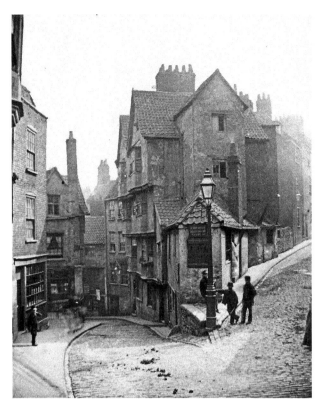

Steep Street at its Most Picturesque, Mid-1850s
Unusually this rare photograph shows some of the Georgian shop fronts in this earlier assemblage. The small wedge-shaped corner shop at the turning to Trenchard Street sold marine stores, but another known photograph showing its window unshuttered illustrates that R. Holloway also purveyed children's kites. The Ship Inn and its lantern appear centrally, while the difficulties posed to large horse-drawn vehicles by the gradient and narrowness of the street are all too apparent.

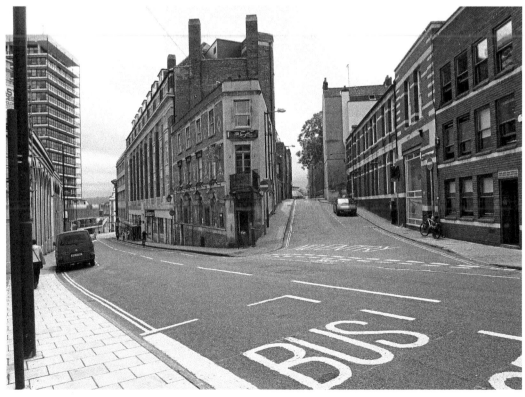

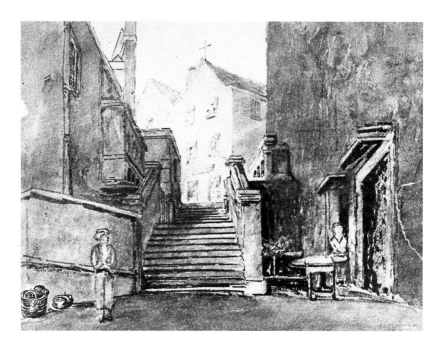

Queen Street and the Griffin Inn, *c.* 1810

A steep path led from Christmas Street up to lower St Michael's Hill until 1669 when vintner and former Sheriff of bristol Jonathan Blackwell paid for it to be metalled and stepped. Called Queen Street by the mayor, Sir Robert Yeamans, it officially remained so until the nineteenth century, although the current name of Christmas Steps was extant by 1775. The 1880s saw the completion of the rebuilding of Foster's almshouses at the left of the picture and the steps rebuilt. The double-gabled Griffin Inn flanked a continuation of Queen Street called Church or Upper Steps that led to St Michael's on the Mount. The inn was demolished when Colston Street was built in the early 1870s and replaced by a tramway depot. It was later rebuilt on the corner of Colston Street and Trenchard Street.

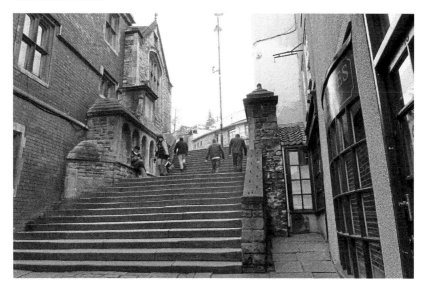

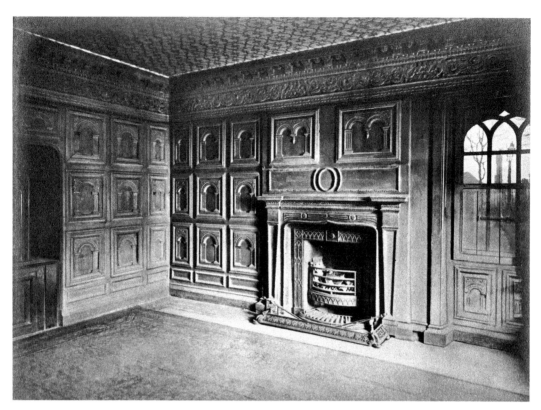

Tudor Panelling at St Michael's Rectory, 1900

The panelled front ground-floor chamber of St Michael's Rectory, Lower Church Lane, looking towards a side window and St Michael's Hill. The rectory dated from about 1470 and was formerly that of St Michael on the Mount church. It was partially refronted around 1775 and given a fashionably Gothic exterior with ogee fenestration by Thomas Paty. Until the 1950s, Lower Church Lane was a picturesque street of small but interesting fifteenth- to seventeenth-century houses. The fine panelling was removed to the Red Lodge in 1910 and is now in the New Oak Room there. Serendipitously it has been realised that its cornice is virtually identical to that already in the Lodge's Great Oak Room and the two are most probably the work of the same craftsman.

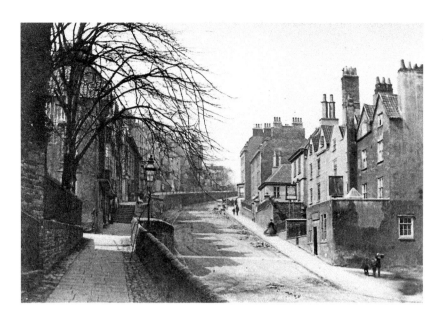

Ascending St Michael's Hill

The hill led not only to Wales and beyond but also to the gallows that stood approximately where Highbury chapel now stands. Because of the gradient, the unfortunates bound for their fatal appointments had their agony extended by the resting of the animals dragging the tumbrels. The Colston Arms and the Scotchman & His Pack on the right still remain much the same today as in Barton's 1860s image. The Scotchman's name has nothing to do with Caledonia, but refers to the delivery of heavy goods by wagon. When making a delivery on such a hill as this, a wedge of wood had to be jammed under the wheels to prevent the vehicle sliding backwards. A man known as a scotchman accompanied the wagon carrying a bag of wedges or 'scotches' in a pack on his back.

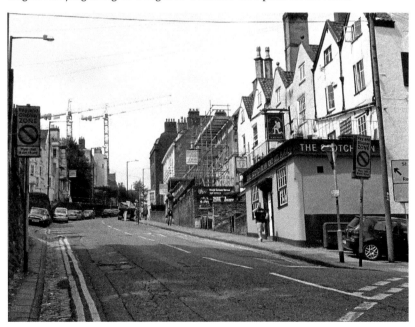

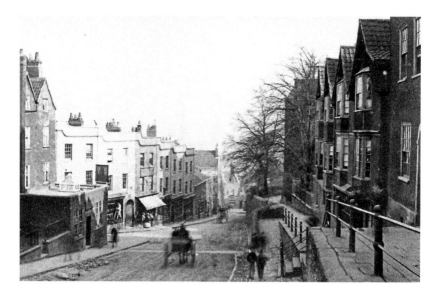

Descending St Michael's Hill

James Malcolm, writing of the view from St Michael's Hill in 1807, stated that even in June the city was so immersed in the smoke from domestic and industrial chimneys that it was impossible to distinguish individual buildings. W. H. Barton's picture of the same view in the 1860s shows much the same shrouded effect in the distance. Apart from the clarity of the air, remarkably little has changed in the foreground. William Gingell's King David Hotel of 1893 unfortunately replaced the earlier ancient hostelry that incorporated remains of the convent of St Mary Magdalen (hence Maudlin Street). The disastrous effect that the tower blocks of the last few decades have had on the city roofscape is easily appreciated in today's photograph.

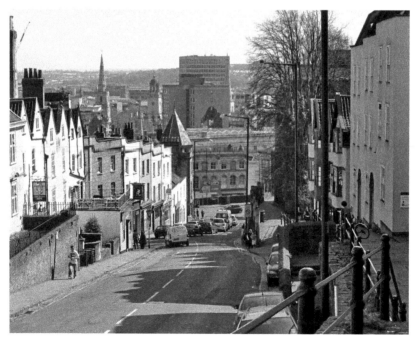

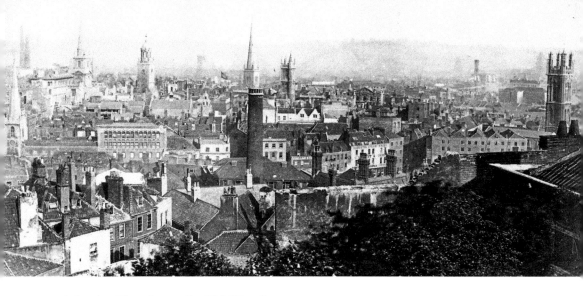

A Sunday View Across the Old City, 1871

Only on a Sunday, when industry and its chimneys ceased pollution, was the air clear enough to see the city with any clarity. This view from St Michael's hill shows just nine of the church spires and towers that then dominated the ancient city before modern high-rise buildings swamped it. From St John's tower at the near-left the line of the inner city wall may be traced in the curve of buildings running towards Corn Street. In the foreground the L-shaped roof of the original Fosters Almshouses may be seen infront of the central factory chimney, and its new wing appears to the right. Its chapel is masked by the gables of the doomed Griffin Inn.

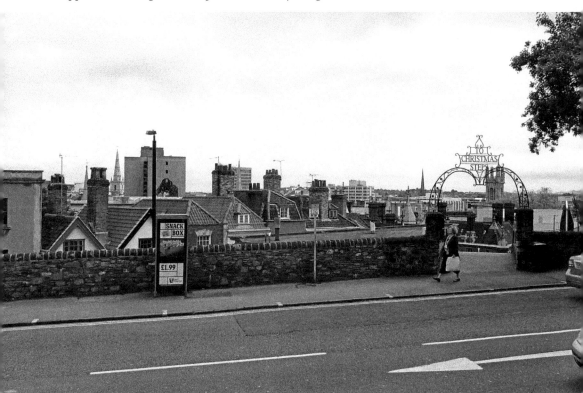

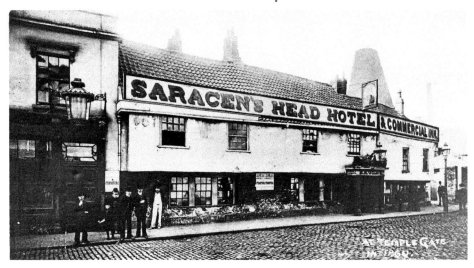

The Saracen's Head, Temple Gate, 1860

The inn's name refers to the Knights Templar's influence in this area. Possibly ancient, the building certainly existed by 1606, but was demolished around 1891, and the Caxton Printing works of Mardon, Son & Hall was later built on the site. Here, a kiln of the Temple Gate Stoneware Pottery rises behind it. Henry H. Giles, the landlord, had the singularity to have been born at the Battle of the Nile. In 1822 the inn had been advertised as having stables for 100 horses, and sheds for carriages. Later in the century its proximity to Temple Meads railway station prompted the claim, 'open to all night trains'. A demolished garage now ornaments the site.

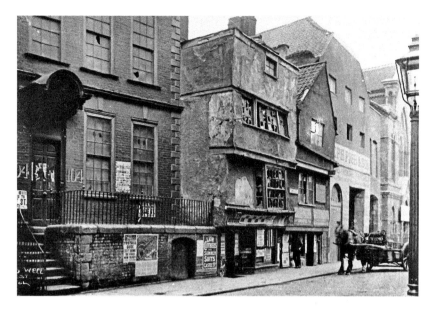

The Crabb's Well, Temple Street

Dating from at least the sixteenth century, its name originated from the excellence of the brew and the saying that clients would find it 'just as difficult to leave as a crab would from a well'. Its walls were massive; those at the side being 4 feet thick. In the eighteenth century a clumsy attempt to modernise the façade led to new fenestration and the masking of the gable with a square topped attic storey. Over centuries the road level had risen considerably necessitating the cutting of steps down to its entrance. It ceased to be a pub many years before the demolition of the row in 1907. Carved brackets from the gabled newsagent's shop were sent to the museum. The loss of the adjoining and late seventeenth-century house with its shell niche was particularly regrettable.

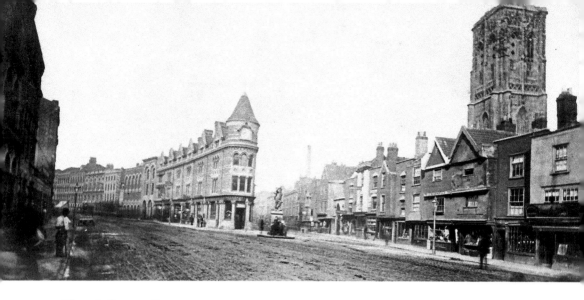

Victoria Street, 1875

In 1845 it was decided to improve the circuitous route to Temple Meads railway station from Bristol Bridge by constructing a new road. However, the Council balked at the cost, and it was not until 1871 that the new Victoria Street was sliced through the historic area at a cost of £50,000. The new business street became associated with firms supplying provisions and spawned a wonderfully harmonious collection of late Victorian brick and stone buildings, as illustrated by this photograph. The road utilised sections of Thomas Street and Temple Street, with its leaning Temple Church tower. The 1723 lead statue of Neptune was moved for the fourth time to welcome travellers to the new road. The last five premises on the right of the photograph were soon to be demolished to improve access to Church Lane.

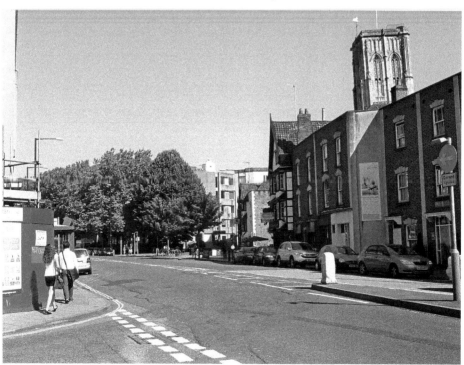

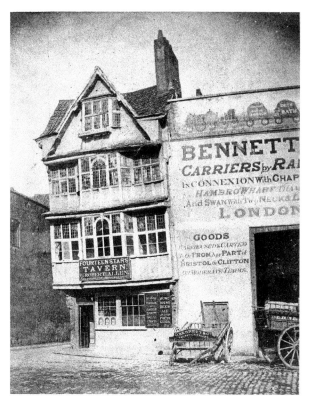

The Fourteen Stars, Countess Slip
This picturesque sixteenth- or seventeenth-century inn stood on the corner of Hawkins Lane and was a favourite haunt of captains engaged in the triangular trade between Bristol, Africa and America. Thomas Clarkson visited it frequently in order to obtain information to aid in abolishing the slave trade. Ironically, after its connection with rum and sugar, the inn was demolished in 1857 to make way for a sugar refinery. Courage's Brewery spread to the site in 1967, but has since been redeveloped. In this delightful early photograph, a modern rail carrier occupies the neighbouring premises.

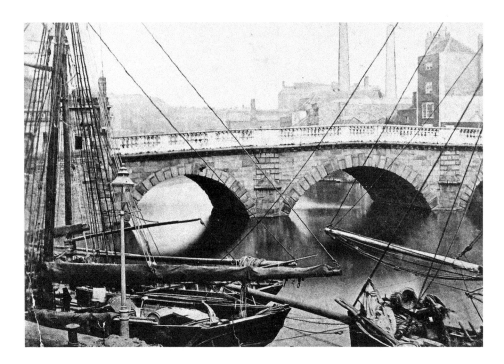

James Bridge's New Bristol Bridge, 1855

The bridge opened in 1768 and was built on its predecessor's piers, in Welsh stone from Courtfield. The bridge's balustrades were of Portland stone and it sported four domed tollhouses. It was the scene of bloody anti-toll riots in 1793. In 1861 a wider pavement, supported on iron cantilevers, replaced the eastern balustrade and toll-houses, amid much public protest at the unaesthetic effect this occasioned. In 1873 the western side received similar treatment. The balustrades may have been removed to the gardens at Kings Weston House.

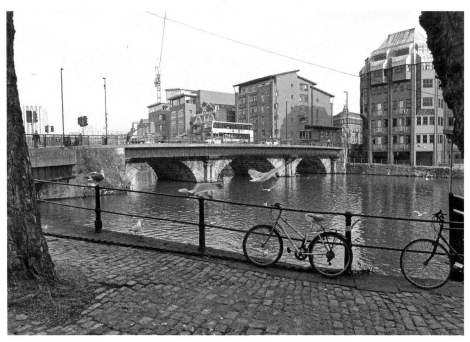

Market Women on the Back, Near Bristol Bridge, c. 1864

The area at the end of Baldwin Street was crowded with handcarts early in the morning. The Back (i.e. 'a street at the back of the water') was a traditional site for dealing in poultry, fruit and provisions, and there was a special quayside building near King Street for Welsh products and dealers – hence 'Welsh Back'. Although of ancient origins, the Baldwin Street so familiar today was sliced through the area in 1881 at a cost of £120,000.

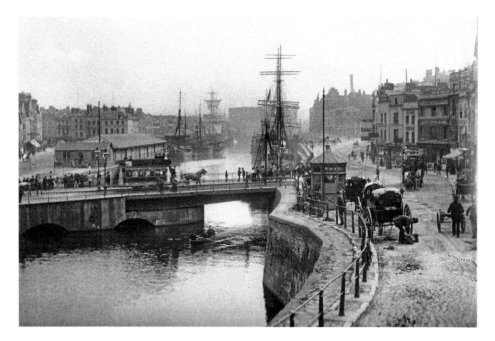

The Drawbridge & St Augustine's Reach, Looking South in 1874

An unusual viewpoint that shows not only the harbour but also the architecture of St Augustine's Parade and far left the rarely depicted early eighteenth-century houses of Thunderbolt Street, demolished for the Co-operative building in 1900. A horse-drawn omnibus crosses the drawbridge, while a row of cabs await their drivers who have taken shelter in the cabman's hut on the right. In the distance the area behind St Augustine the Less's churchyard wall is massed with industrial buildings, and in the centre Bush Warehouse looms large.

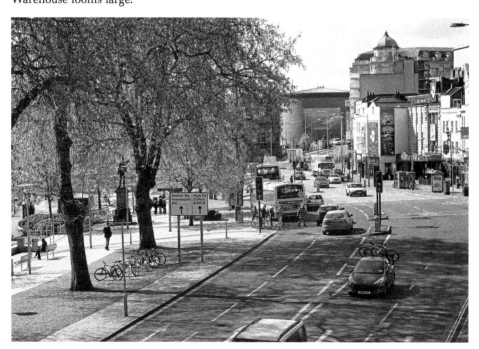

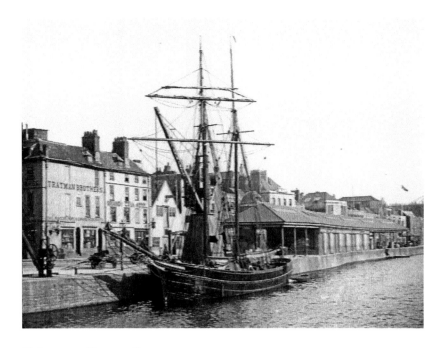

Picturesque Narrow Quay

A rare 1880s view showing the last house of Thunderbolt Street and the Brandy Cask Hotel on the corner of Alderskey Lane on the left, while to the centre right, and behind the stretch of goods sheds, the substantial high pitched roof and four windows of the western façade of the Assembly Rooms are visible. This rarely photographed façade bears a pediment emblazoned with the legend 'CWS', denoting its decline into a warehouse for the Co-operative Society. That organisation gradually bought up the entire block and demolished it to build their new depot, which opened on 16 May 1906. The demolition displaced 240 residents from the old houses, closed five public houses in the area, and is an indication of the density of population within the city at the time.

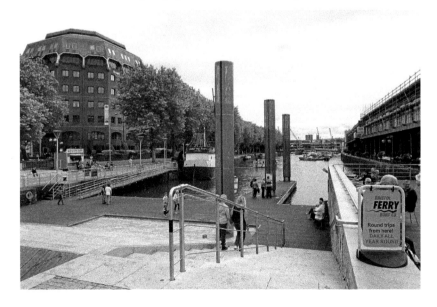

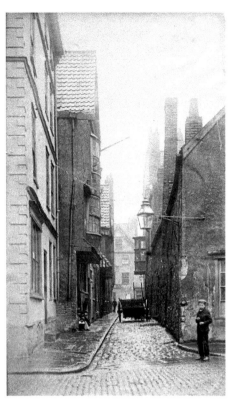

Alderskey Lane

This extended from Prince Street to Narrow Quay. The name derived from Aldworth's Quay, by which that section of the 'Key' was once known. At the north-western side of the junction with Narrow Quay, a late seventeenth-century brick residence (then, the Brandy Cask Hotel), adjoined a timber-framed house that had been modernised in late Georgian times with a pair of attached bow windows on the first and second floors. A boy stands outside of the Albion Tavern on the corner of Prince Street. The lane was demolished in around 1900 to make way for the Co-operative Society's warehouse. A fireplace of 1682 and previously in the Goat in Armour Inn that adjoined the house on the near right is now in the Wigwam at the Red Lodge.

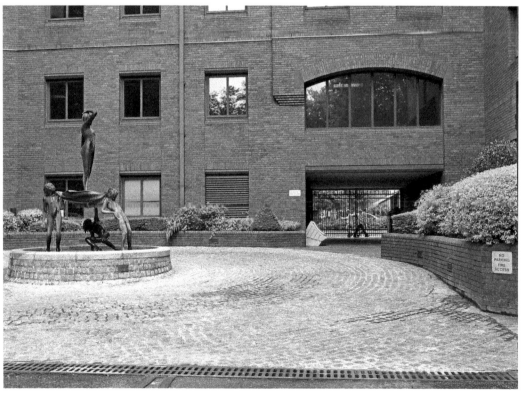

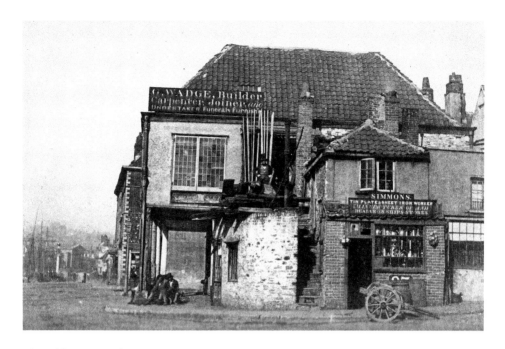

The Old Corn Market on Narrow Quay, *c.* 1849

Grain brought by sea was traded in this seventeenth-century building whereas land imports went to another on Wine Street until 1726. The quayside building, adjoining Currant Lane, became private business premises until demolished around 1849 for street widening. Left of its portico is the Brandy Cask Hotel at the corner of Alderskey Lane while, in the distance, is the classical façade of the new St Mary on the Quay. Left of this appears the famous quayside sundial, a column topped by a dial and a golden ball, which had survived for over 200 years on Narrow Quay until replaced in 1862 by a row of goods sheds that were despised for their tastelessness.

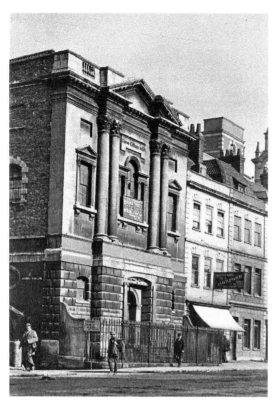

William Halfpenny's Bristol Assembly Rooms in Prince Street

Opened in 1756, its façade bore the legend 'Music Dispels Care'. The ballroom's two fireplaces confronted six statue niches below windows positioned to prevent the company from being overlooked. Acanthus ceiling roses held four lustres. A musicians' gallery clasped the eastern wall while the western bore a clock framed by elaborate rococo plasterwork and pilasters ornamented with musical instruments and theatrical masks. Doors opened to the drawing room and a coffee room below it. Only open to visitors and permanent subscribers they were never a great success, resulting in their closure in 1810. Modified, they reopened in 1811, as a theatre displaying 'Equestrian and Pantomimic exercises'. The building later became a GWR and Co-operative Society warehouse until 1906, when it was sold and demolished to the ground floor. In 1956 this also was finally swept away.

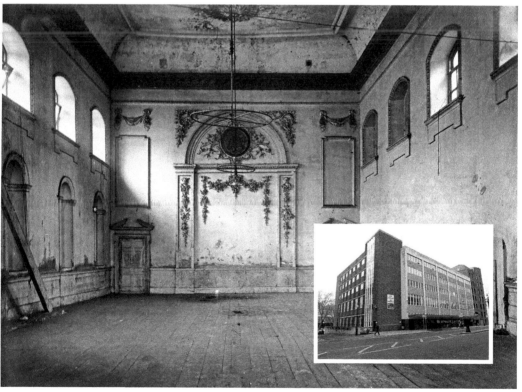

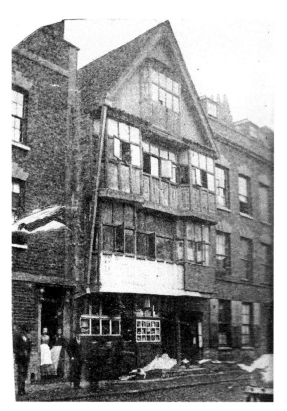

Judge Jeffreys' House, King Street, 1880
This rare but damaged photograph
shows the house that was once the
residence of John Romsey the Town
Clerk, where the notorious Judge Jeffreys
lodged when he arrived in Bristol in 1685
to hold the Bloody Assize following the
Monmouth Rebellion. The chair used
by Jeffreys found its way as a curiosity
into the City Library in King Street and
is now in Bristol Reference Library, in
urgent need of restoration. The house
bore the date 1664 on its front door and
the initials J. R. S., presumably for John
Romsey. The façade was distinguished
by its great use of glass on the principal
floors and by panels decorated with
classically inspired pargetting. It stood
opposite the gateway of the Merchant
Venturers' Almshouses and was
demolished in the 1890s.

Walk 5

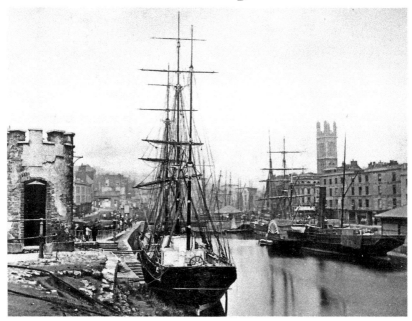

St Augustine's Reach, Seen From St Augustine's Back, *c.* 1870
The castellated building in the foreground, with decaying stucco cladding, had once been topped by a signal flag-staff that was used by the Water Bailiff and the Quay Warden. By this time, however, it had degenerated into a gentlemen's urinal. The adjacent river bank, on which the Watershed now stands, retains its natural slope. The drawbridge erected across the harbour in 1868 may be seen in the distance. A paddle steamer is moored near the Sedan Chair public house that survived until the mid-1970s.

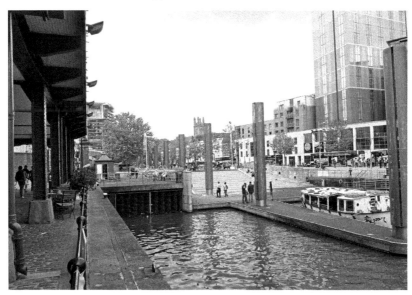

P. Barnet's Russian Fur Manufactory
This drawing from the 1820s shows the historic buildings that once stood at the foot of College Green, adjoining St Augustine's Back and the corner of Mark Lane. Although given modern fenestration in the previous century and provided with a false front and lamp bracket at the right, the buildings are obviously from earlier centuries. The rather 'raggle-taggle' collection of structures in Mark Lane includes one showing a medieval archway in its side wall. St Mark's chapel may be glimpsed at the far end. Barnet's is dotted with fire assurance plates and a huge carved eagle or phoenix supported by two shields, a survival of earlier days, the significance of which is now lost. The buildings were swept away by 1859 for a new convex terrace designed by Charles Dyer.

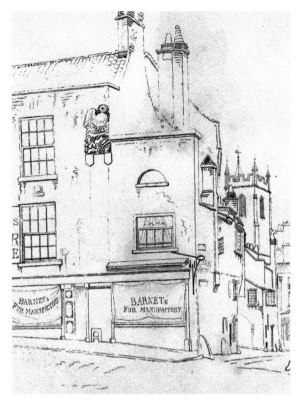

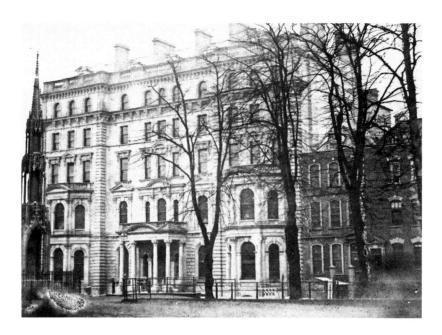

The Royal Hotel, College Green, 1868

Out of scale and towering brightly above its Georgian neighbours the new hotel rather resembled an overblown villa. Unsurprisingly, its architect, William Henry Hawtin, specialised in domestic architecture, although his use of alternating pediment types in the Hellenistic manner added some interest to the façade. It replaced a row of private houses and even at the time was criticised for its dominance. Seen here in a rare photograph, it opened on 23 March 1868 boasting 120 apartments with 'respectable young women' acting as chambermaids. In the late twentieth century it closed and became derelict. It was, however, redeveloped with a new wing built on the neighbouring site of St Augustine the Less – a gem of church wantonly demolished after damage in the Second World War. A cast-iron canopy has replaced the original classical entrance portico.

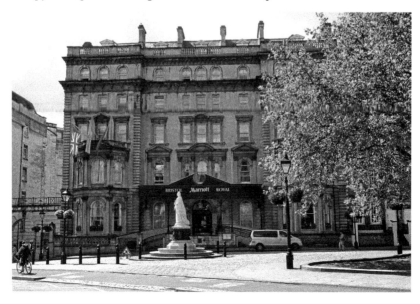

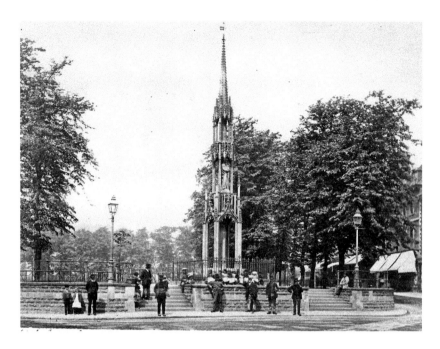

The New Civic High Cross, 1860

The history of Bristol's magnificent medieval High Cross is shameful to relate. The original now stands at Stourhead, given to Henry Hoare by Dean Cutts Barton in 1768 having been moved from its historic location, re-erected on College Green and then again dismantled following complaints from promenaders on the Green that it impeded their passage. In 1851 a replica was erected, but money did not run to statues and only Edward III was added in 1855 by the Freemasons. Seven more were added in 1889 following the cross being moved to the centre of the Green to make way for the new statue of Queen Victoria. With the lowering of the Green in 1950 the cross was dismantled and suffered such neglect and vandalism that only the top section was rescued and now stands in Berkeley Square.

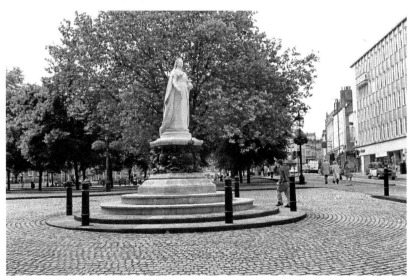

65

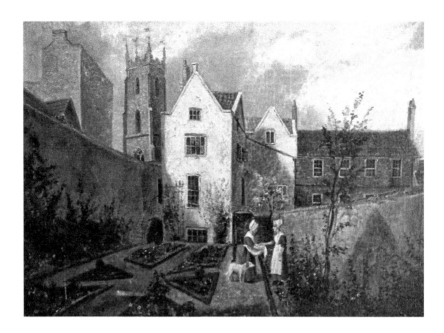

The Garden at Red Maids' School

This early nineteenth-century oil attributed to Samuel Jackson shows the whitewashed 'New Mansion of the Gaunts', part of the Gaunt's Hospital complex of which Lord Mayor's Chapel was the church. It was the original building given in the 1627 will of John Whitson for the education of forty poor female children, who were to be apparelled in red, and wear white aprons. Although enlarged by a brick extension in the eighteenth century the buildings, set on the steep slopes of the College Green plateau, became inadequate and, following an abortive effort to move to Queen's Road, a new school was built on the original site in 1840–42. The school moved to near Westbury on Trym in 1930. This painting is particularly important as evidence for the design of a small town garden of the seventeenth or eighteenth centuries.

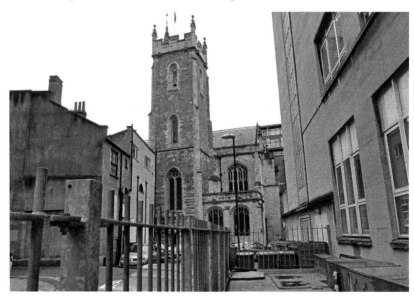

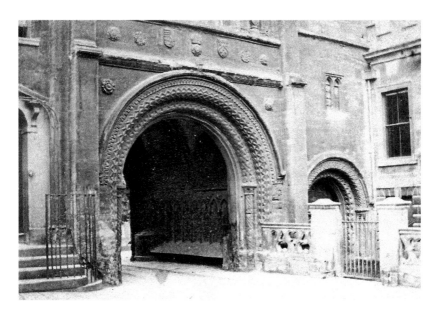

The Gatehouse and the Deanery in the 1860s, by William Barton

Even in the eighteenth century the fine condition of the Romanesque decoration was marvelled at, although Southey remarked that the stone had been eaten away at the base through urination. The threat of such and worse 'nuisances' are the reason for the internal corner bosses and sloping shelves. Until June 1761 the archway had been gated and access under the control of the Dean and Chapter. To save the expense of a porter the gates were removed and it thereafter became a public way. To the left, the Precentor's House appears while on the right is the ancient Deanery that stretched across, to beyond where the Council House now stands. The wing was removed for the construction of the Deanery Road viaduct in 1869; Charles Holden's Central Library replaced the remainder after 1902.

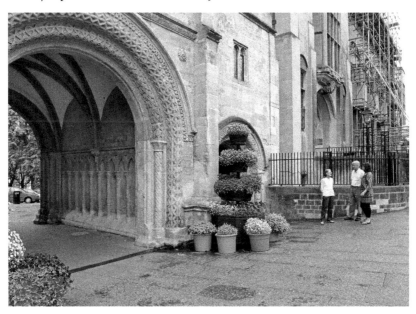

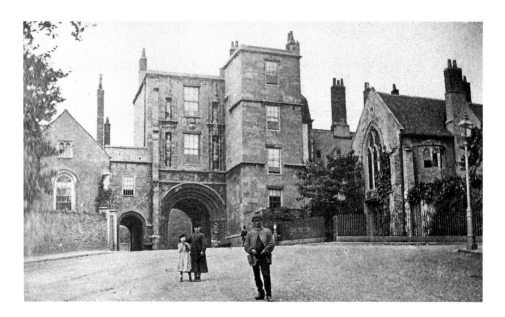

Lower College Green and the Norman Gateway in the 1870s

On the left the medieval Deanery was demolished in 1902 for Holden's City Library. Adjoining the arch on the right was the eighteenth-century Precentor's House and the Chapter Office; both disappeared in 1881 as the cathedral was rebuilt. Far right is the ancient Minster House that was one of the few parts of the Augustinian monastery still surviving. In the early nineteenth century, the organist, Dr Edward Hodges lived there calling it 'Prior's Lodge'. He installed a great gothic window and planted the trees seen in the photograph. To the dismay of antiquarians it was demolished in 1884 by the Dean and Chapter who thought it unworthy of the new works. One of the windows was saved and installed in the garden of Downfield Lodge, Downfield Road, Clifton.

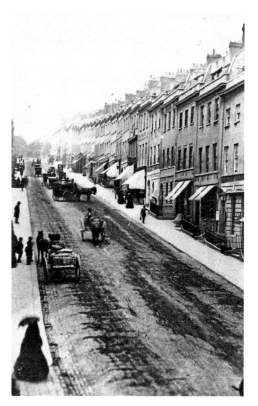

Park Street Ascending 1866, by W. H. Fox
The stepped terraces of Park Street were
constructed in stages between 1761 and 1800.
The houses were mostly by the Paty family
and much the same in appearance, apart from
the architectural treatment of their front door
surrounds. These presumably reflected the
fashion of the decade in which they were
constructed. The south side was uniform
with pilasters and triangular pediments while
the north had pediments, arched or Tuscan
entrances. All had substantial railed areas
and semi-basements now obliterated. Until
the building of R. S. Pope's viaduct in 1871,
all traffic was faced with the considerable dip
down into Frog Lane when leaving from and
arriving at the College Green plateau.

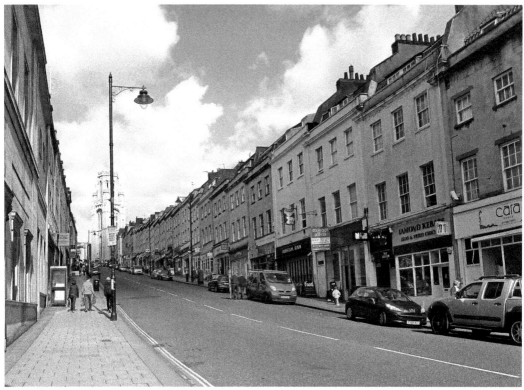

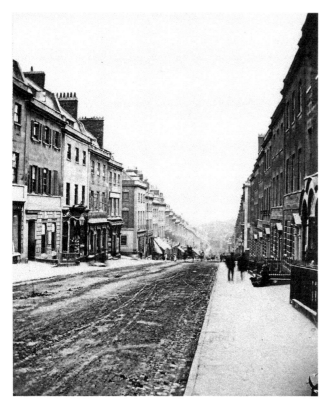

Park Street Descending, 1865

'A spacious and well built street (little inferior to the entrance to London at Oxford Street).' Until the development of Miller's nurseries that lined Whiteladies Road, Park Street formed the new entrance to Bristol for travellers from the Severn Passage. When the house on the corner of Park Avenue was built, a pole as tall as the building and bearing the royal standard was erected on the pavement to mark the limit of the city; it appears in this photograph. It is commemorated on a milestone in Westbury on Trym village. By 1865 a number of the houses had been turned into fashionable shops. Always genteel, as late as the 1960s guidebooks still referred to it as the 'Bond Street of the West' before high rates and rents ruined many a business.

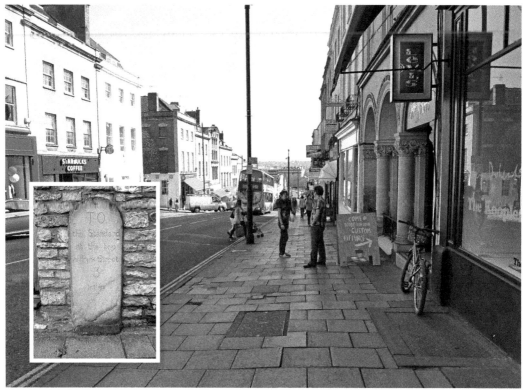

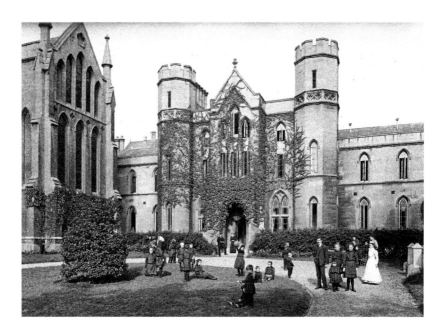

The Bristol Blind Asylum, Queens Road

Adjoining Bishops College, on the site now occupied by the Wills Memorial Building of the University of Bristol, it was founded in 1793 by the Quakers Bath & Fox. The buildings themselves dated from 1838. The Asylum's purpose was to teach trades to the blind and to find them employment in shops. The building was arranged around an entrance courtyard with a large chapel, just visible to the left of the photograph, located where Oatley's great University Tower now stands today. The Asylum followed much the same ground plan as the buildings that would replace it. By 1906 the premises were no longer adequate for their purpose and the buildings were sold.

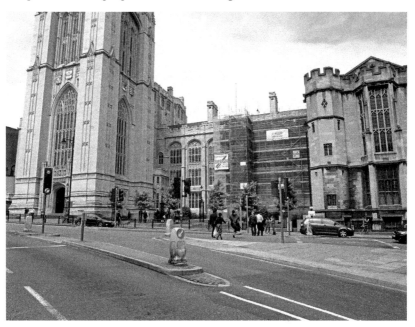

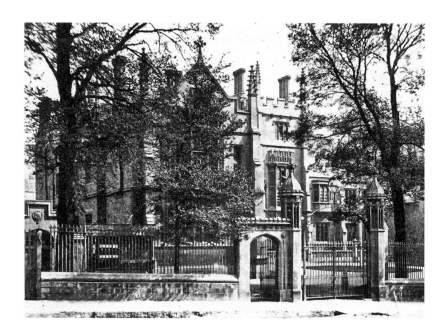

Bishop's College, Queens Road, 1865

Built for the Red Maids in 1839 but deemed too grand, it was sold instead to the Bishop of Bristol, whose Church of England school occupied it from 1841. In 1861 a volunteer rifle club purchased it as a clubhouse, building a huge drill hall behind in 1862. Bristol Library Society occupied the wing nearest the gates before moving into the new and adjacent museum in 1871. Between 1888 and 1896 the Conservative Salisbury Club occupied it until ownership of the site passed to the Council. They demolished the buildings for the 1905 Municipal Art Gallery. Much of the College's Gothic architectural decoration was incorporated into several large houses that were then built in Coombe Lane, Coombe Dingle by William E. Studley. One, named 'Salisbury House', recalled their origins.

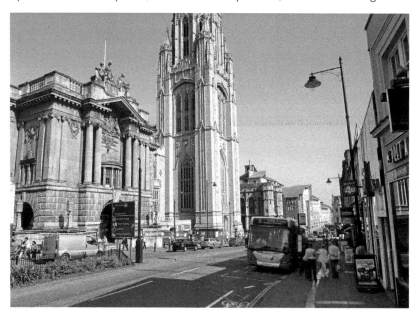

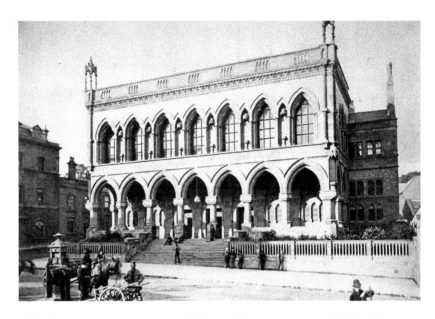

Bristol Museum – Foster & Pontin's Venetian Extravaganza in the 1870s
Opened in 1872 to house the combined collections of the Bristol Institution and the Bristol Library Society, this remarkable building was dogged by misfortune and debt from the start. Insolvency prevented many of the planned decorative features, including the carved capitals from being completed, although members realised that the building looked grotesque without them. On 14 October 1877 gales destroyed much of the western parapet. In 1892 Sir Charles Wathen paid its debts and the Corporation took it over. In 1894 W. V. Gough was commissioned to finish the sculptural decoration according to Foster's original drawings, but further misfortune followed when an incendiary bomb hit the building during the Blitz. 'Restoration' sliced off most remaining decoration and it suffered more damage when converted to its present use.

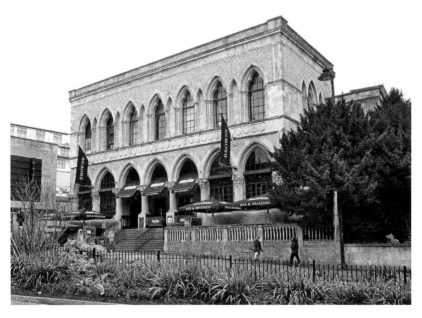

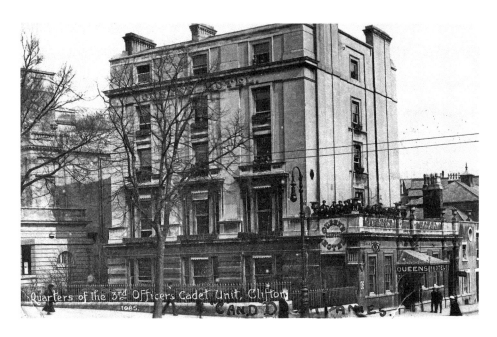

The Queen's Hotel, Queen's Road

Designed by W. B. Reed and opened in 1854, it was the first of a series of modern hotels that would spring up in the city over the next two decades. Architecturally it is interesting in that it combines both classical and Italianate styles, and relies greatly for effect on light and shade with its simple giant pilasters and chimney stacks. Requisitioned during the First World War for the 3rd Officers Cadet Unit, C and D companies appear in the picture as the added inscription notes. Post-war it started a new career as a series of department stores, a transformation that saw the destruction of the original ground floor and garden.

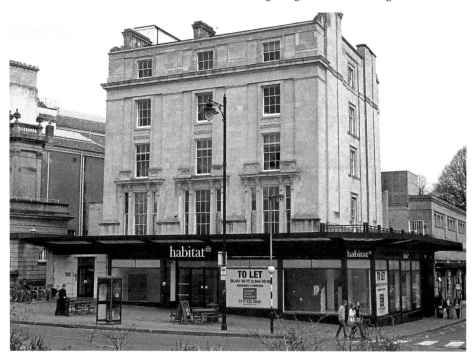

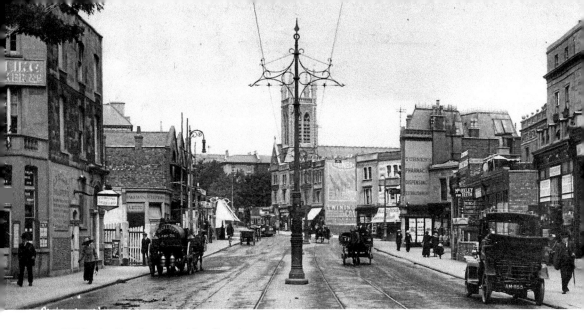

White Ladies Gate, Looking North, *c.* 1912

On the right is the gallery of King's Royal Arcade. By 1912 many of the houses in this section of the road had lost their gardens and were given over to commercial uses, although the gateposts beyond the motor car on the right show that Woodville House still survived domestically. Trelawney cottage next to the arcade still sported a rooftop balustrade and a show of ball finials. To the left, a lamp-oil tanker waits outside an undertaker's and the premises of Pakeman's monumental sculptors by the entrance to Clifton Down Station's coal yard. Smart modern shops then occupied what is now Clifton Down shopping centre, while Henry Crisp's Tyndale Chapel of 1867 had yet to face its bombing and rebuilding.

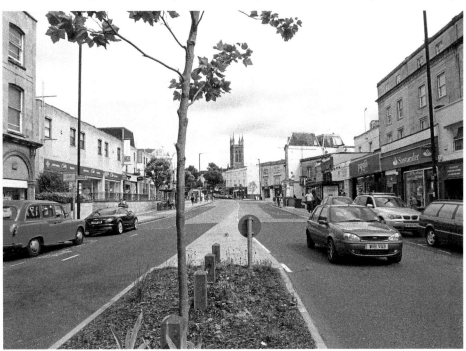

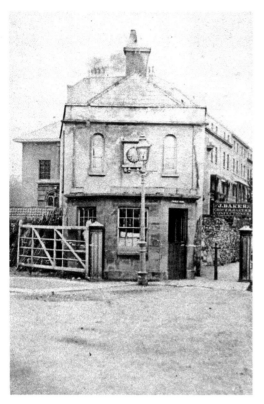

White Ladies Gate in the 1860s

Barton's previously unpublished photograph appears to be the only record of the double-gated turnpike that gave the junction between Cotham Hill and White Ladies Road its name. Following the passing of the Turnpike Act in 1866, and until their removal in November 1867, there were some fifteen 'obstacles to locomotion' within Bristol and 18 miles of toll road. Until the 1850s a noisome open sewer ran along Whiteladies Road from Durdham Down, meeting and draining with others by Whiteladies Gate and 'escaping over a large area' around what is now Alma Road. By 1873 the turnpike and neighbouring grocer's shop had been replaced by Joseph William King's Royal Arcade, with its eight (now six) statues of English kings and queens. The actual arcade lay behind the existing building and became a bank and then a public house in the twentieth century.

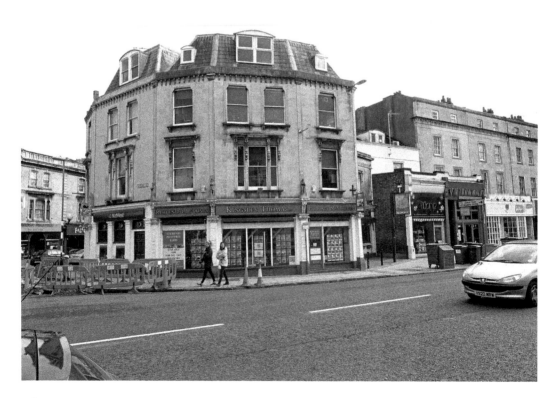

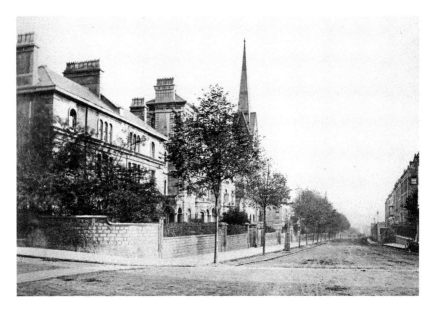

Whiteladies Road from the Corner of Burlington Road in 1873

Beyond the pair of semi-detached villas on the left are William Bruce Gingell's handsome trio of Italianate houses of 1856. The central house now remains almost unchanged, but the outer ones, with flanking towers, have lost their ground-floor bays to shopfronts. Fripp & Ponton's Redland Park Congregational church with its Germanic spire was a victim of the 1940 Blitz and was replaced by Ralph Brentnall's simplified Gothic building in 1955–57. King's Parade, on the right, was once the grandest terrace of houses in the hamlet of Durdham Down, but was demolished in 1902. St John's Parish Rooms would be added in the churchyard on the far right in 1874. The number of religious establishments in this road prompted a late Victorian wag to rename it the *'Via Sacra'*.

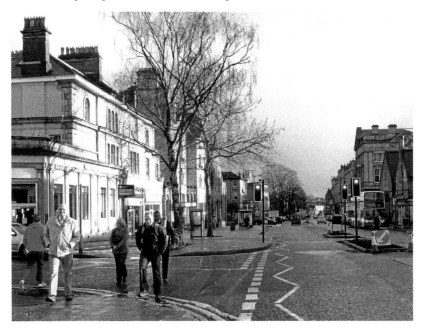

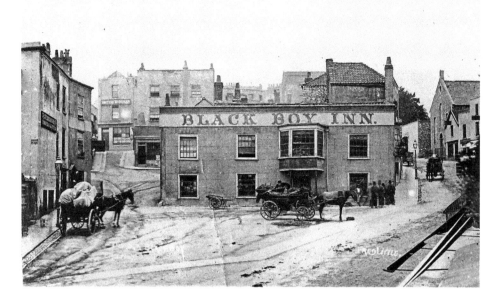

The Black Boy Inn, Durdham Down

Originally called the Blackmoor's Head, it dominated the road to Westbury-on-Trym and eventually gave its name to the hill on which it sat. The presence of the British Workman Temperance 'pub' at the left rear, with its curtain emblazoned 'Tea Coffee Cocoa' dates this photograph to at least the late 1860s. The Methodist chapel on the right was built in 1849 and later became the Mount of Olives Pentecostal church. It is now a gymnasium. The building on the far left bears the legend 'Lydeard Place'. After 1874, this interesting collection of squares and houses was mostly demolished for road widening.

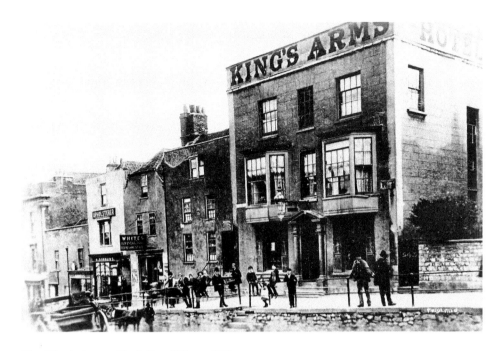

The King's Arms, Black Boy Hill, *c.* 1888

This substantial inn seems to have been established in Durdham Down hamlet at least by 1826 and possibly earlier. An extension with a first floor bay overlooked the small shrubbery to the right and was bounded by York Street. Later in the century advertisements proclaimed its livery stables and carriage hire. Wedding carriages were a speciality. The raised pavements and surrounding buildings have a pleasing country town appearance that was lost when the inn was rebuilt in 1897 to the Tudoresque designs of Holbrow & Oaten.

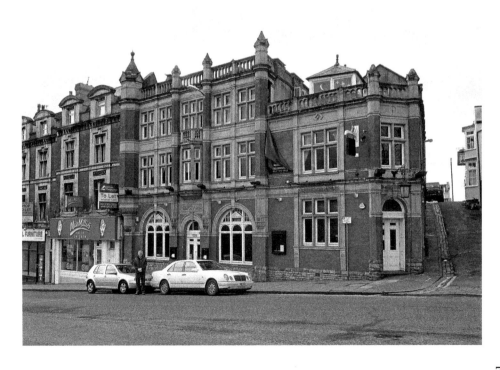

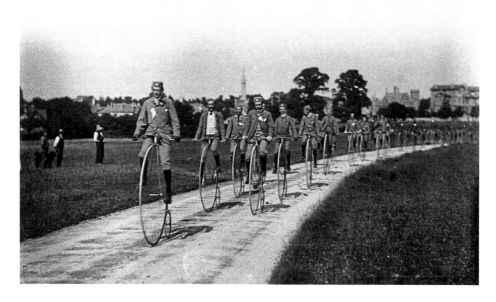

Clifton Bicycle Club parades on Saturday 24 July 1886

On the horizon stand several houses in Rockleaze together with the tall, thin spire of Stuart Coleman's newly-built Christ Church that was demolished in 1961. The Bristol and West of England Bicycle Meets had attracted competitors since the 1870s. It became a tradition for the cycling competitors to parade on a circular route from the Zoological Gardens to Sea Walls and then back prior to the commencement of the event. In 1882 more than 200 riders took part. Thousands paid the shilling to attend the sports and enjoyed brass bands and often firework displays. Before 1889 and the establishment of a racing track at the County Ground, 'meets' had to make do with the Zoological Gardens on ground that was said to be neither conducive to 'good times or graceful riding'.

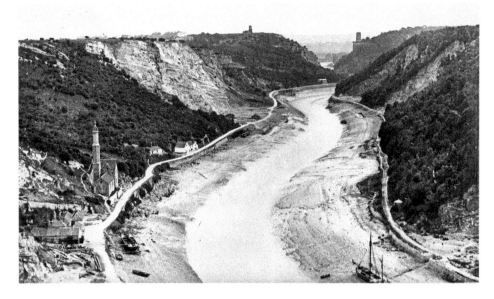

Water Springs Engine House from Wallis' Wall (Sea Walls) Before 1864
The Merchant Venturer's waterworks of the late 1840s were built to pump water from springs near Black Rock to a reservoir on Observatory Hill. Ultimately the supply proved inadequate for Clifton and water was brought from elsewhere. The delightful Tudoresque engine house featured an octagonal chimney complete with a cap in the form of a pierced Tudor onion-dome. Beyond it, the whitewashed buildings had once comprised the pump room and lodging house of the New Hot Well that tapped a second hot spring known as St Vincent's. Lack of carriage access resulted in its closure and by the 1790s it was used for housing quarrymen. A drinking fountain was erected on the spot in 1894 and survives today, while the spring may still be discerned at low water. In 1864 the buildings were demolished for the Port Railway.

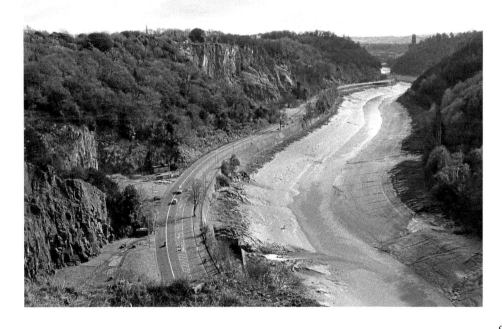

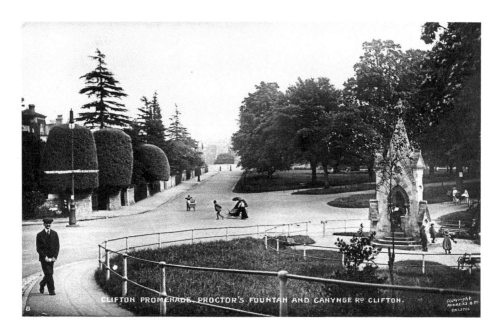

Clifton Promenade and the Proctor Fountain, *c.* 1900

Perambulators, an invalid carriage and a street hawker comprise the only traffic at what is now a dangerous road junction. On the left the lavish 1850s mansions of Clifton Down display their topiaries, while to the right children take refreshment at Alderman Proctor's fountain. Proctor gave this to the city in 1872 and then in 1874 he donated the Mansion House. Both structures were designed by George and Henry Godwin. The Clifton turnpike had originally occupied the fountain site and its gates stretched to the first house on the left. In 1988 the fountain was declared a traffic hazard and moved across to the triangular green opposite.

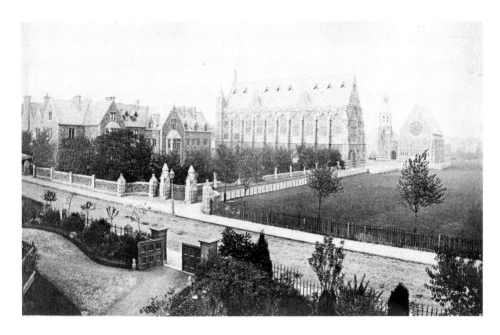

Clifton College from Oakleys, *c.* 1875

Charles Hansom's splendid new college buildings seen across the newly planted garden of Oakleys House. The College had been founded as a boarding school for Bristol boys on the lines of Rugby and was formerly opened in 1862. More buildings were added as the institution prospered. The photograph not only shows Hansom's original college gateway, later replaced by Charles Holden's memorial arch, but also the lost gates and railings of Oakleys boarding house, and is an interesting record of a shrubbery planting of the era.

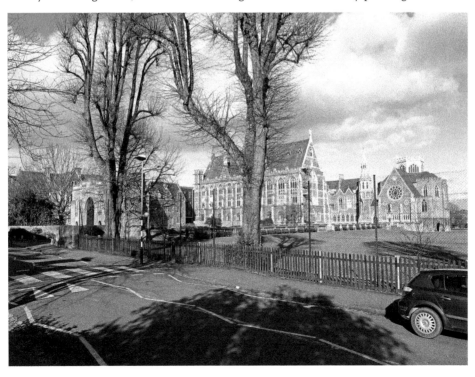

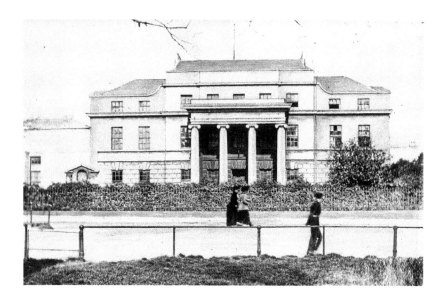

Manilla Hall; Clifton in the Late 1880s

Built by General Sir William Draper and named after his victory at the siege of Manila. To the far right of the entrance portico, in the garden south of what is now Manilla Road, he erected a cenotaph to the regimental dead in his 1758–65 East Indies campaign. To the left of the entrance (on the lunette shaped lawn created by the carriage drive and in front of the façade's statue niche), he placed an honorary obelisk to William Pitt. In 1882 the hall became a convent and the monuments were rescued and re-erected opposite the house through the efforts of Dr John Beddoe. Manilla Road was laid out through the south garden in this period and its houses gradually encroached on the hall, which was finally demolished in the early 1900s.

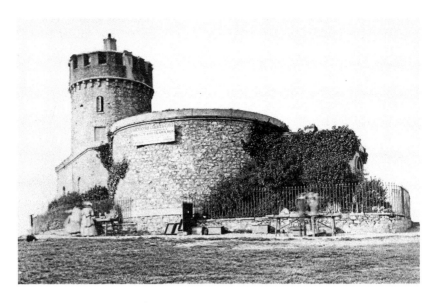

Clifton Observatory in the Late 1850s

In 1828 the remarkably inventive artist William West rented the ruined windmill on Clifton Down and erected a house on the site. The following year he turned the tower into an observatory, complete with telescopes and a splendid camera obscura. He then excavated a tunnel from the building to reach, by 1837, the Ghyston or Giant's Cave, that opens from the cliff face some 90 feet from the summit of St Vincent's Rocks. Visitors continued to pay the sixpence to visit the building throughout the century and to enjoy its attractions. From the tables outside they were sold minerals, fossils and ornaments such as obelisks, crosses and candlesticks all made from the polished stones of the gorge. The lost ivy-mantled rooms to the right of the house included the entrance with its large Romanesque door.

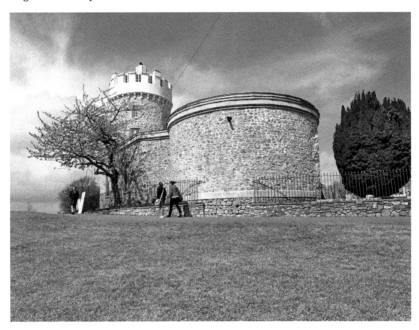

Walk 6

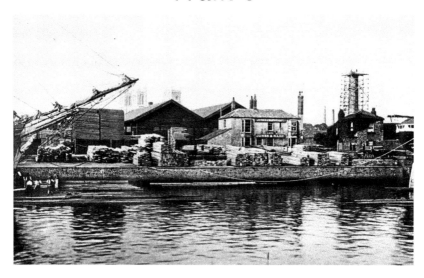

Canons Marsh and Jones & Wainwright's Timber Yard

The Cathedral's towers and the unfinished chimney of the Rowe Brothers' City Works suggest an image date of 1889, a time of transition for a place previously semi-rural, with the riverside alone devoted to saw mills, timber merchants and ship building. It had mostly retained its natural sloping riverbanks, and the main drain from the abbey and at least one stream crossed it. An historic ropewalk occupied the area south of Anchor Lane and a gasworks was established slightly down river in the 1820s. The whole character of the area changed after 1900 when the Canons Marsh wharf was constructed and huge transit sheds rose. It changed again in recent years and it is now mostly given over to much sadly uninspiring office and domestic architecture.

47–77 College Street from the Deanery Road Viaduct, 1940

In 1770 an estate was developed on the Bishop's Park, and Luke Henwood's College Street was the first part erected. The small estate of elegant red-brick middle class houses and smaller working-class properties clustered between Lime Kiln Lane (now St George's Road) and below the plateau that was College Green. Both Southey and Coleridge were residents. The construction of the Deanery Road viaduct across it in 1869 lowered its desirability and, in 1950, it was sold off in lots. The street survived the Blitz, but Bristol planners demolished it along with surrounding properties, for a temporary car park in 1959. Bryan Brothers' Garage was constructed on part and subsequently replaced by flats, permanently blocking this viewpoint from Deanery Road. College Street now barely exists.

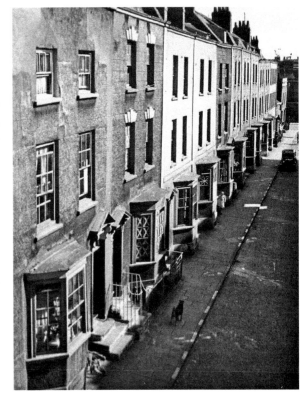

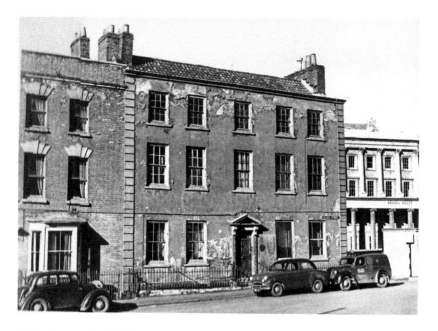

Friese-Greene's Birthplace

On 7 September 1855 William Friese-Greene was born at 12 College Street, the substantial Georgian house shown in the photograph. He became a pioneer in the field of motion pictures, but started his career as a portrait photographer. In 1955 the Lord Mayor unveiled a commemorative plaque to Friese-Greene on the façade only for the house to be demolished by the Council for an open-air car park in 1958. The plaque is now attached to the nearby Council House. Planning blight had caused the properties of College Street to become neglected, but the photograph shows how well the area had worked visually. Brunel's Great Western Hotel in College Place may be glimpsed beyond. The Council House's construction blocked the historic route from College Green to Hotwells, turning this area into a backwater.

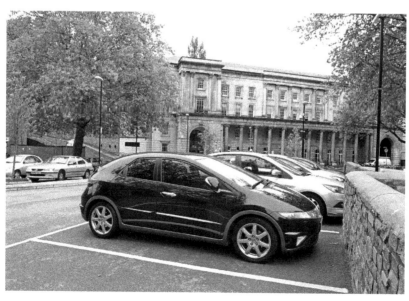

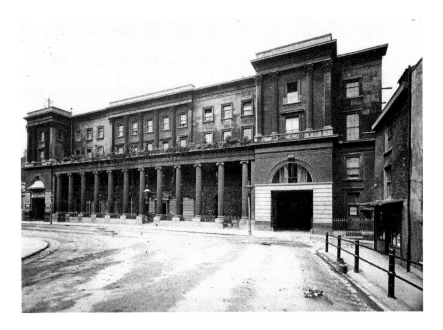

Royal Western Hotel, St George's Road

Opened in April 1839 to replace Reeve's Hotel, its primary function was, like its predecessor's, to accommodate steamer passengers. Brunel saw it as a vital link in his rail and sea Atlantic trade. The hotel was in view and close to College Green, and on the main route to Hotwells and embarkation, so the location was not strange as some have claimed. Bristol was bypassed as more convenient ports expanded their trans-Atlantic facilities and the hotel closed by 1855. In 1859 it re-opened as Bartholomew's Turkish bath and survived as a hydro until the 1950s. In 1982 it was converted into Council offices. The left hand arch led to stables and the right to a magnificent horse bazaar that predated both hotels. The long and apsidal structure was originally built in 1791 as an equestrian theatre to display exhibitions of horsemanship.

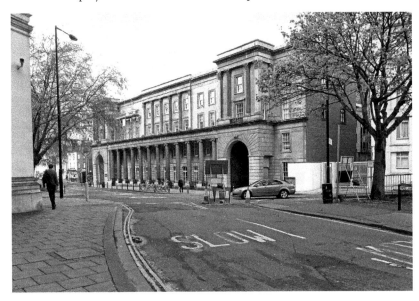

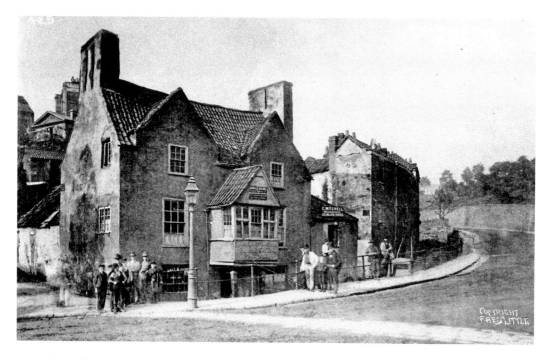

The White Hart, Woodwell Lane (Jacob's Well Road)

A rare but damaged photograph taken in 1877 before demolition. White Hart Lane (now 'Steps') runs to the left of the building and on the right stands a group of decayed houses known as Lambwell Court. The Inn was probably where Henry 'Orator' Hunt established his brewery, the Clifton Genuine Beer Company, in 1806 using only the 'Best Malt and Hops'. It was succeeded in 1882 by St Peter's church, Clifton Wood, that lasted until 1939. On the site today stands a block of flats named St Peter's house.

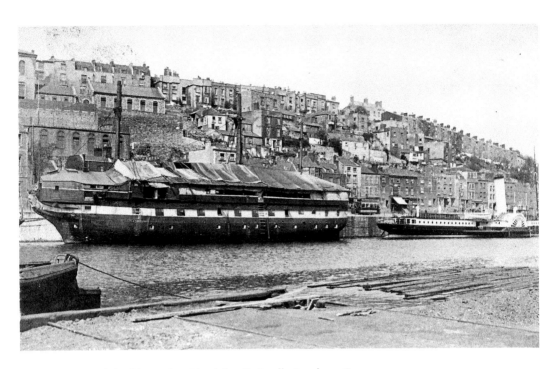

HMS *Daedalus* Moored at Mardyke, Hotwells Road, *c.* 1890

Launched in 1826 as a fifth-rate frigate, she was never actually commissioned and was cut down to a corvette in 1844. In 1848, while *en route* to St Helena, Captain McQuhae and several of his officers and crew saw and studied a 60-foot sea serpent at very close quarters for twenty minutes. This was subsequently reported in detail to the Admiralty and debated in the *Times* and *Illustrated London News*. In 1851 *Daedalus* became a training ship, and transferred to the Royal Naval Reserve as a drill ship at Bristol. She was sold to the breakers in 1911. In the eighteenth century, the sloping hillside here bore a highly profitable series of hanging gardens and orchards famed for their early produce.

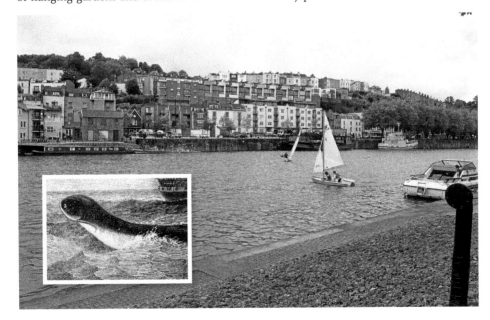

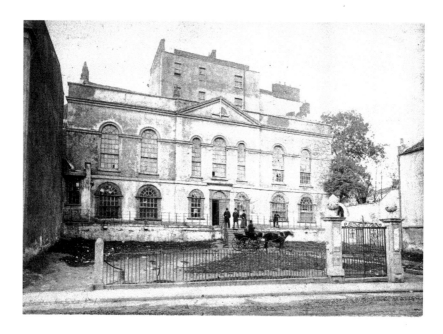

The Royal Gloucester Hotel, 1889

Opened in 1722 as the Hotwell Assembly Rooms with an attached hotel and gardens, by the 1790s, under James Barton, it had become an architectural wonder and described as 'a house upon a house'. Barton constructed a towering six-storey annexe behind the original building with a circular central staircase illuminated by a skylight and suites of rooms enlarged by rows of bay windows on three sides. Two bow-fronted buildings were built as an adjacent extension at this time and survive. By the 1850s its fortunes had waned and it had lost the enlivening attraction of the bay windows from its façade. Demolished in 1889, the Haberfield almshouses were built in its gardens. A row of villas now occupies the site of the original building. This rare photograph comes from the Mike Tozer collection.

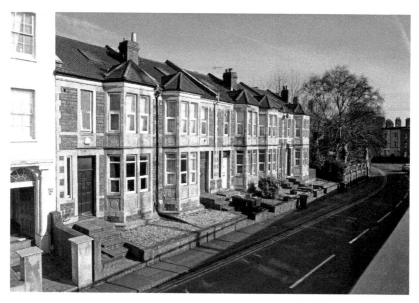

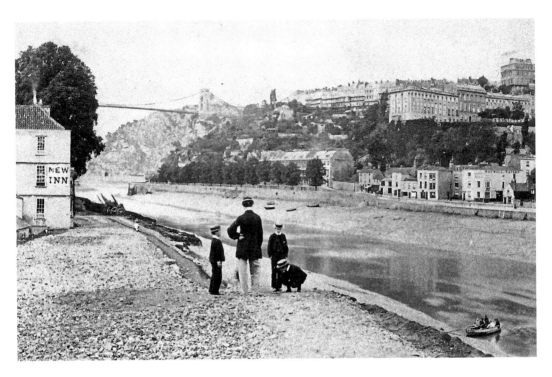

Hotwells & Clifton from the New Inn

The presence of the finished bridge and the existence of the Hotwells pump room in the distance date this photograph by Francis Bedford to about 1865. Rownham Ferry may be seen at the water's edge. By the 1880s it would move to the Cumberland basin to serve Clifton Bridge Station on the Bristol & Portishead Railway that opened in 1867 and ran behind the New Inn.

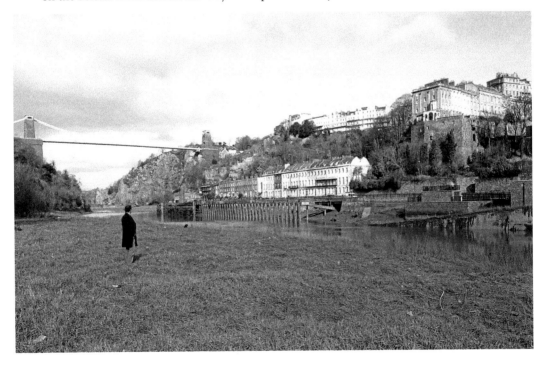

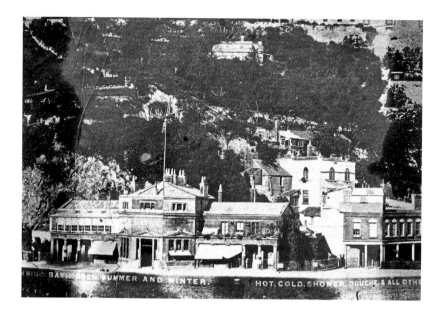

A New Pump Room, 1822

The original Hotwells House was removed to aid the passage of ships up the Avon and this rare, but damaged photograph shows its replacement in around 1855. Doric colonnades, their lower parts at one time painted in Pompeian red, flanked a polygonal central block. The building included a *camera obscura*, the lens of which may be seen above the entrance while its other delights were listed on the riverbank wall. In June 1867 it was demolished in order to completely remove Hotwell Point – an inconvenient prominence on the bank of the Avon that hindered navigation. To the right, part of the colonnade, built to provide an all-weather promenade and shops for visitors, appears and still remains intact. It would later be shortened to its present length.

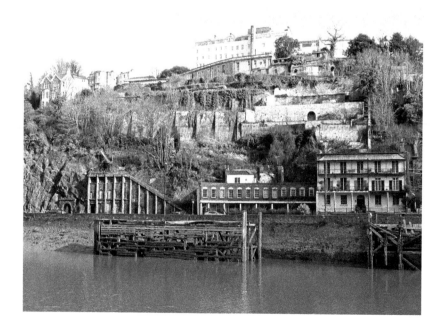

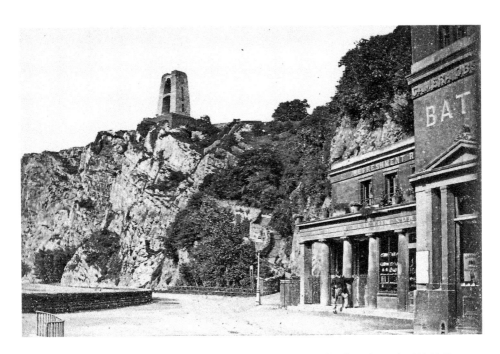

The Royal Clifton Spa and Bristol Hot Wells Pump Room in the 1850s, by W. H. Barton
An attendant stands by the entrance to the souvenir shop that sold such essentials as flesh rubbers and brushes, stools, cigars, Hotwells toothpowder, umbrellas and, surprisingly, boomerangs! Minerals and fossils from the gorge, in natural state or made into fancy objects, were sold and can be seen in the window. These included the famous Bristol Diamonds and Landscape Marble from Cotham. Refreshment rooms occupied the upper floor of this wing.

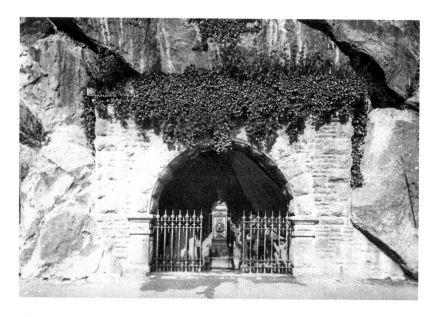

The Hotwell Pump & Attendant, *c.* 1886

After the new Pump Room was demolished in June 1867 in order to aid navigation of the river, the spring became inaccessible to the public for a decade. In 1877, however, an ornamental cavern was cut into the cliff face and the spring was piped to it for public use. The pump, that was manned permanently, was of classically eclectic design. Topped by entwined dolphins, its cornice had a figure holding the reins of two hippocamps while the water flowed from the mouth of a river god whose mask ornamented the pedestal. Chained brass cups hung either side of the pedestal. Sadly the water proved to be no longer warm and it was questioned whether the correct spring had been tapped. This blurred photograph is now possibly the only image remaining of the installation at this period.

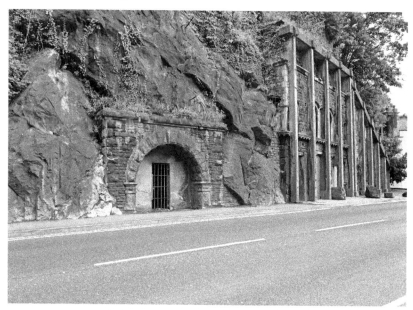